JULIAN PHOTOGRAPHY

TED W. SNODDY

Copyright 2011
JULIAN PHOTOGRAPHY

First Edition April 2011

All rights reserved. No portion of this book my be reproduced, stored in a retreival system, or transmitted in any form except for brief quotations in printed reviews without the written permission of the author.

Digital photographs by the author in most representations, with minor exceptions.

Author: Ted W. Snoddy
Julian, California

Printed by Lulu Publishing
Lulu.com

Published and printed in the U.S.A.

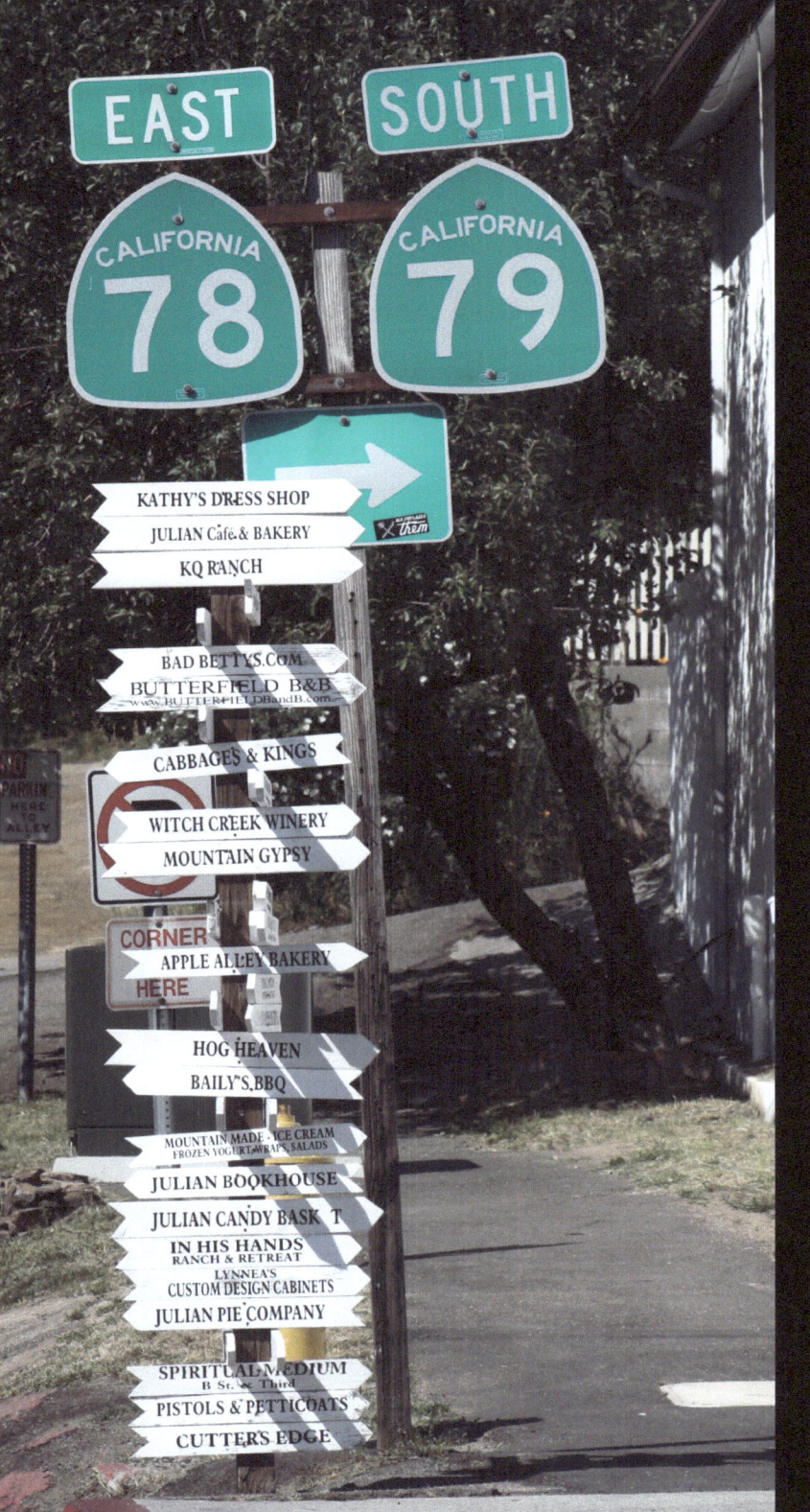

The Julian Sign Post

Directions to everything in town.

Where you will find places to see, flowers to smell, animals to pet, apple pie to eat and rusty things to collect.

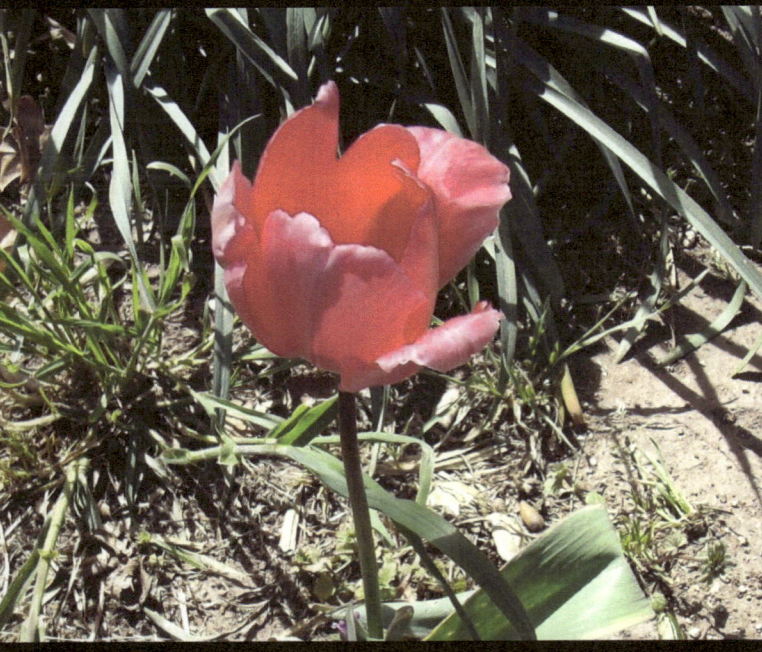

Flowers & Daffodils in Julian

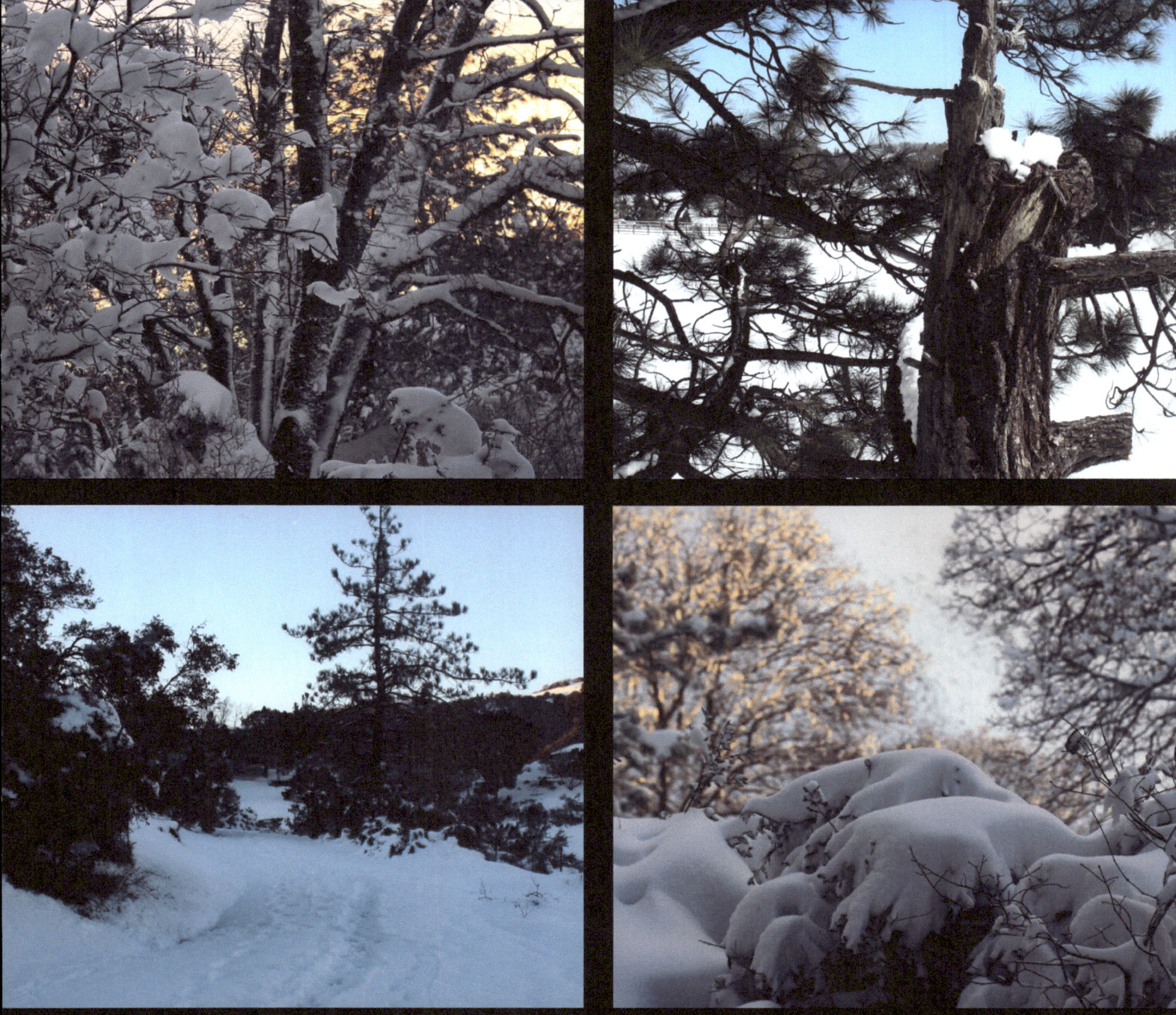
Sunrise after a recent snowfall in Julian

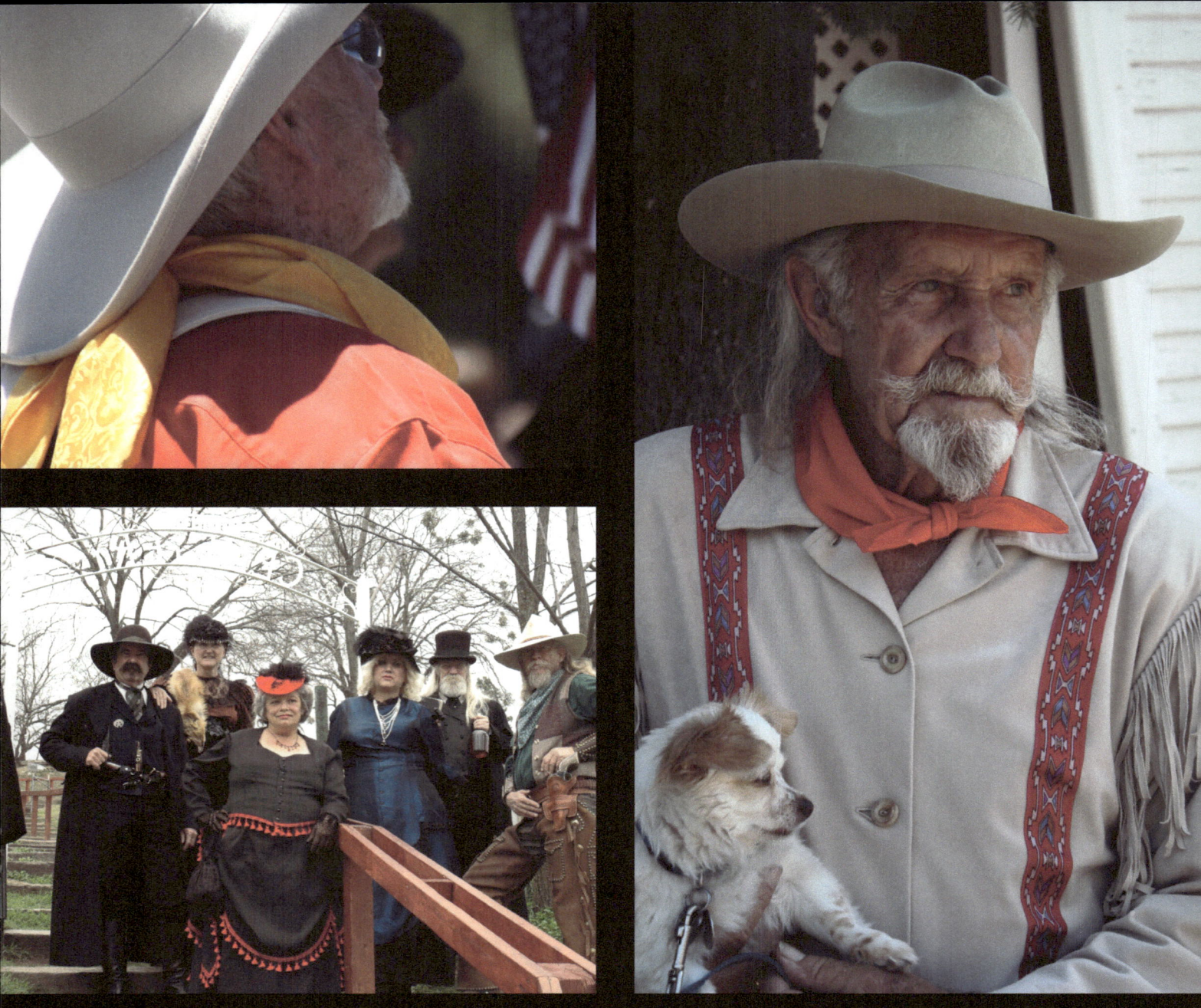

Julian's Doves & Deperados, Cowboys and Wild Bill "Ace" Hickok and Partner-in-Crime, Teddy

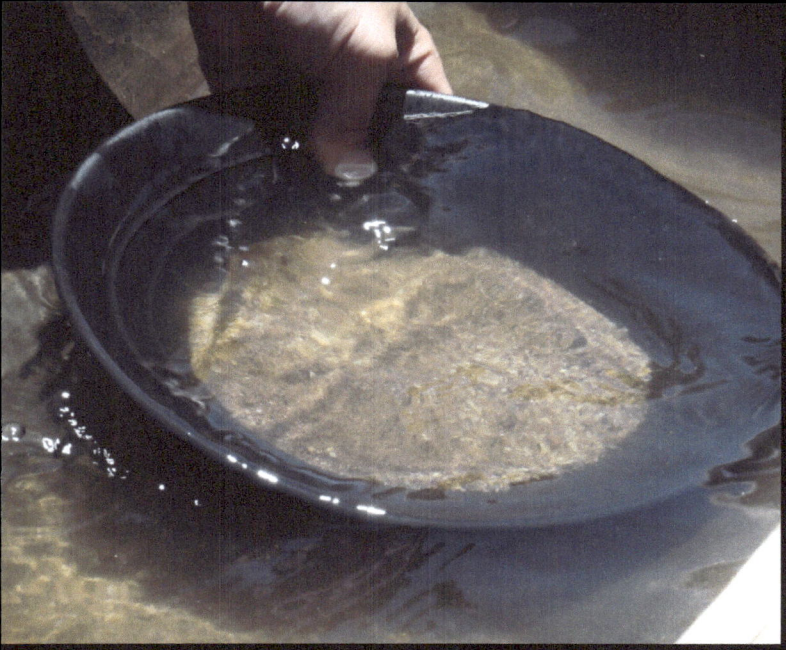
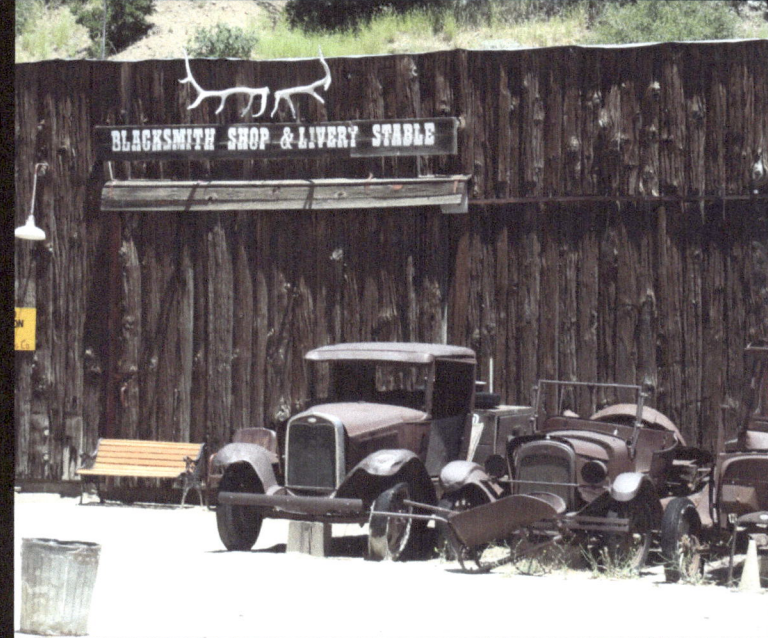

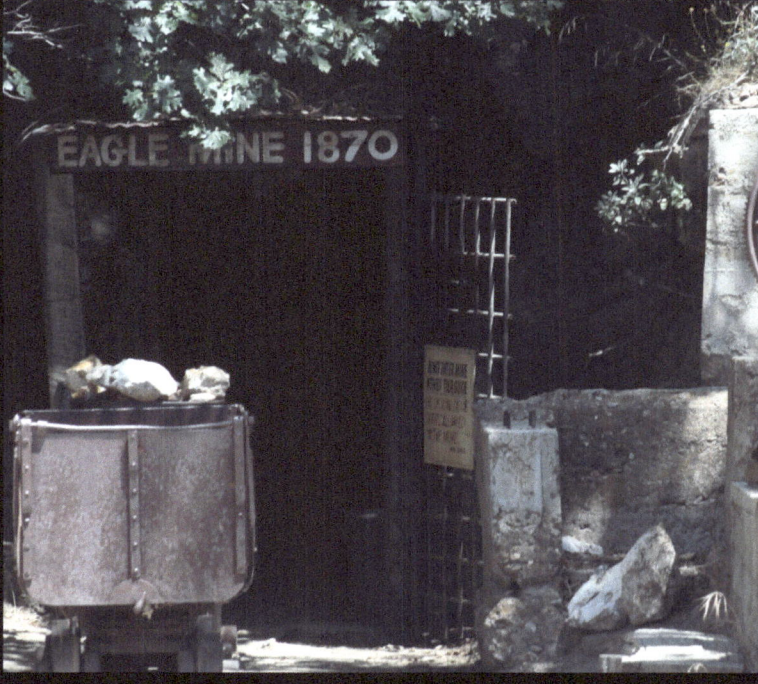

Eagle Peak Mine, tours & panning for Gold

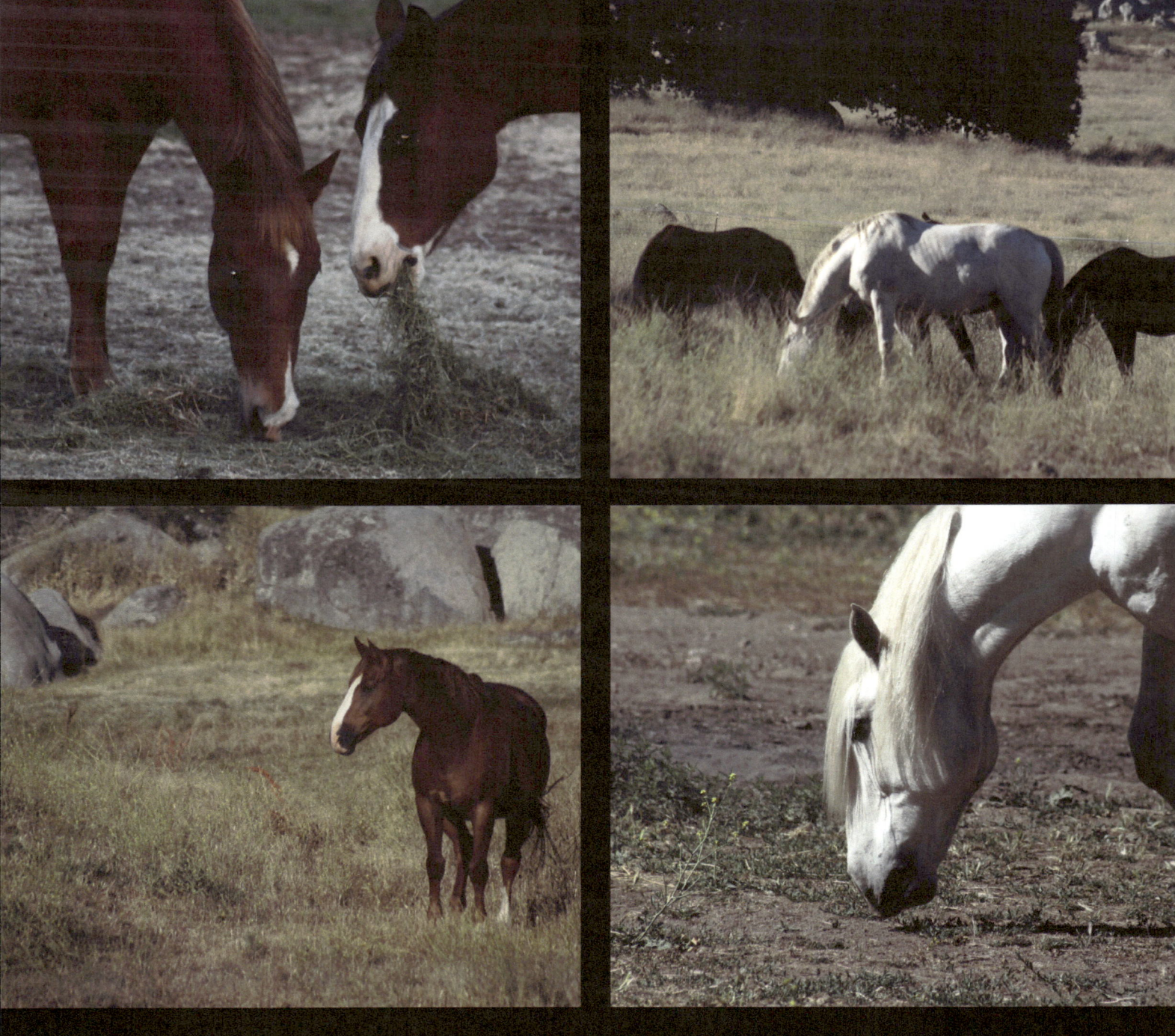
Cowboys, horses, stables & riding trails in Julian

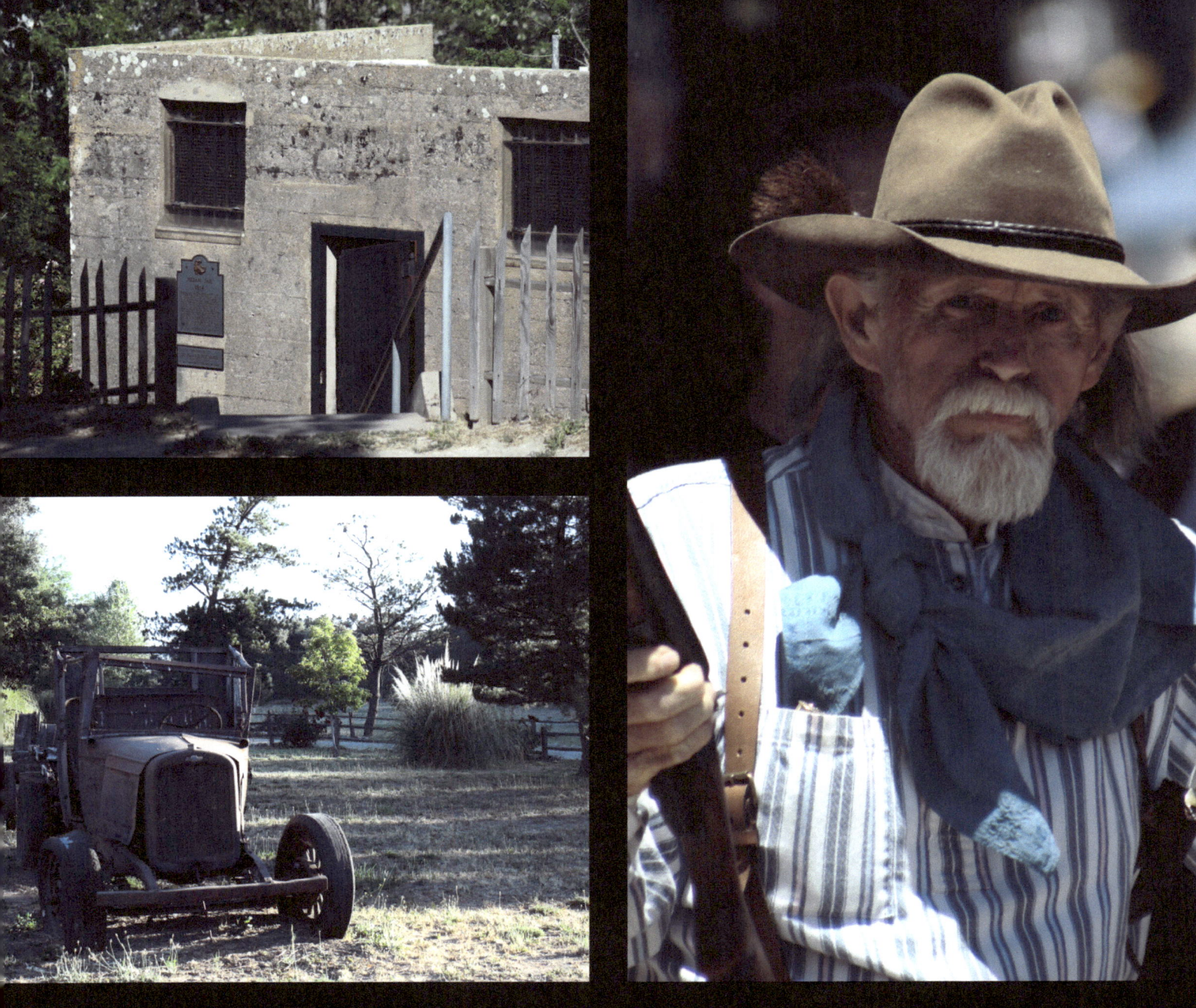

The Julian Jail (1873) rebuilt in 1914 - Old and Rusty Things

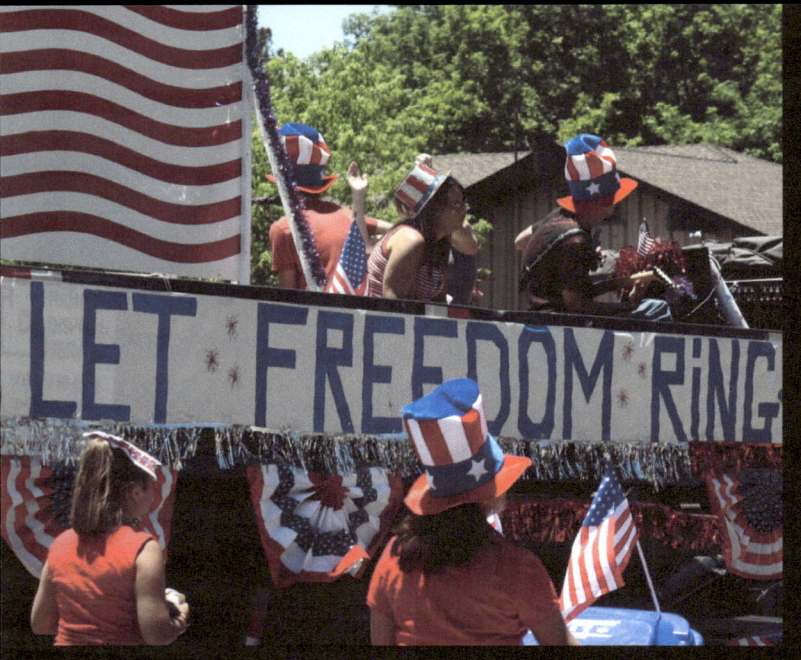
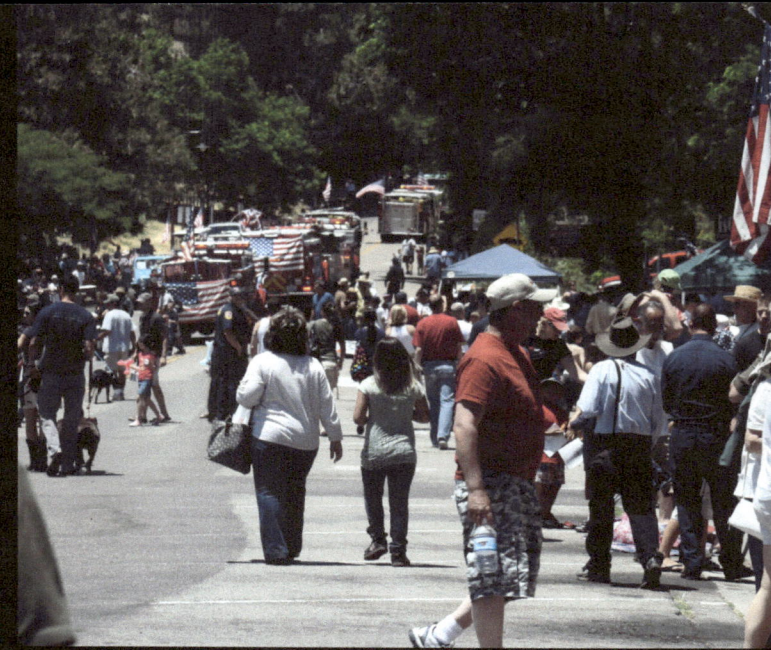
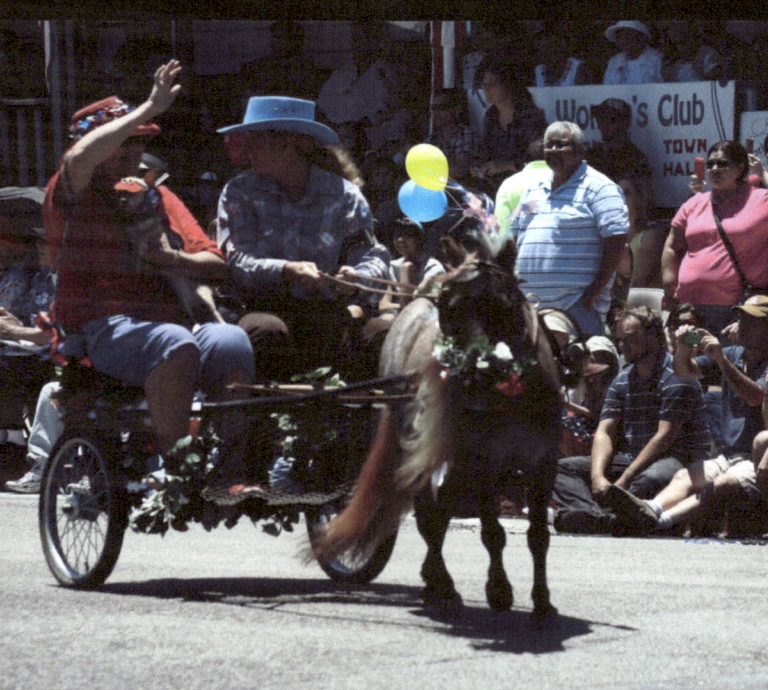
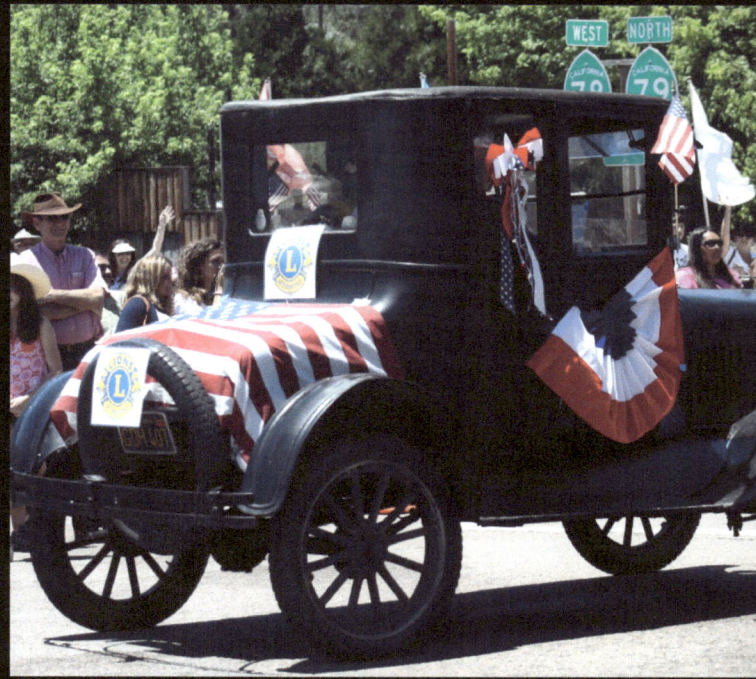

Julian's Annual 4th of July Parade

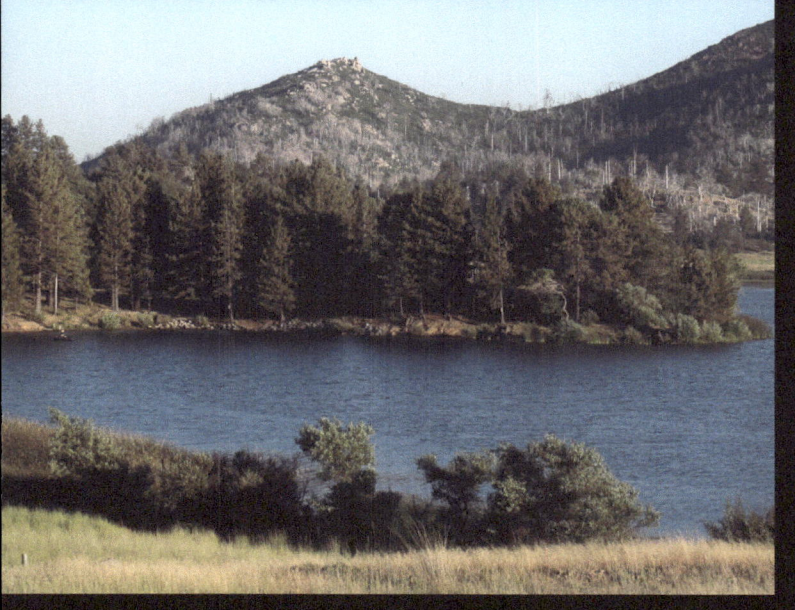
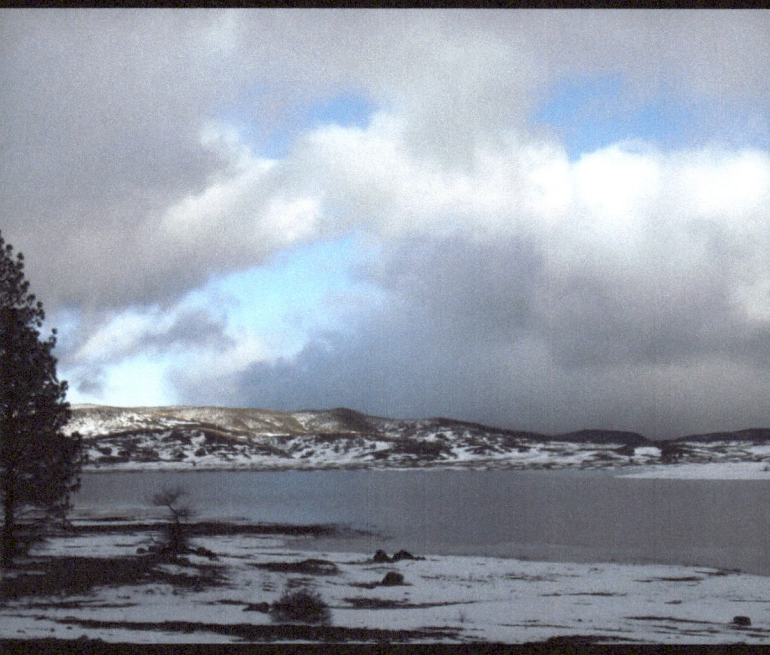

Lake Cuyamaca

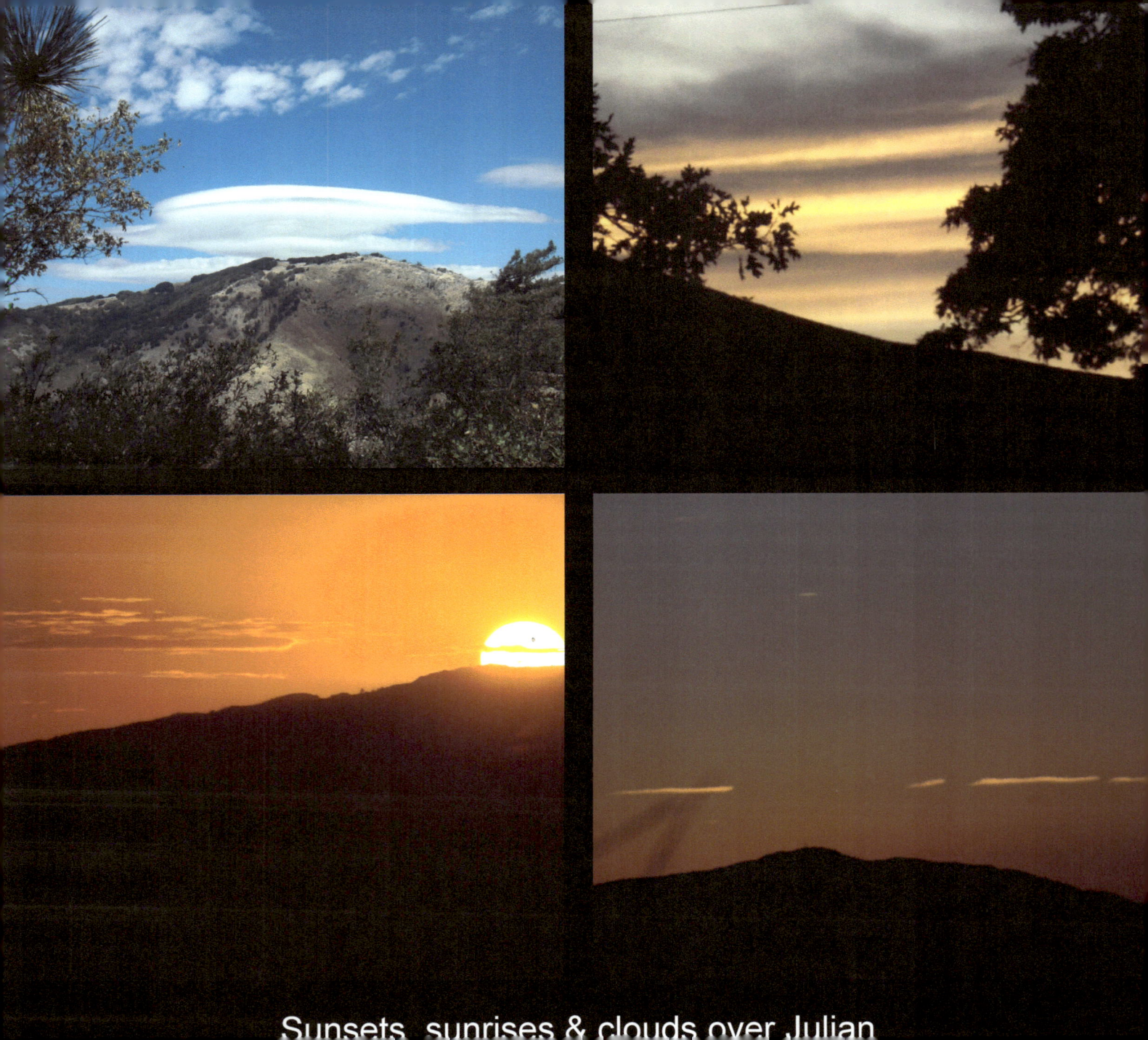

Sunsets, sunrises & clouds over Julian

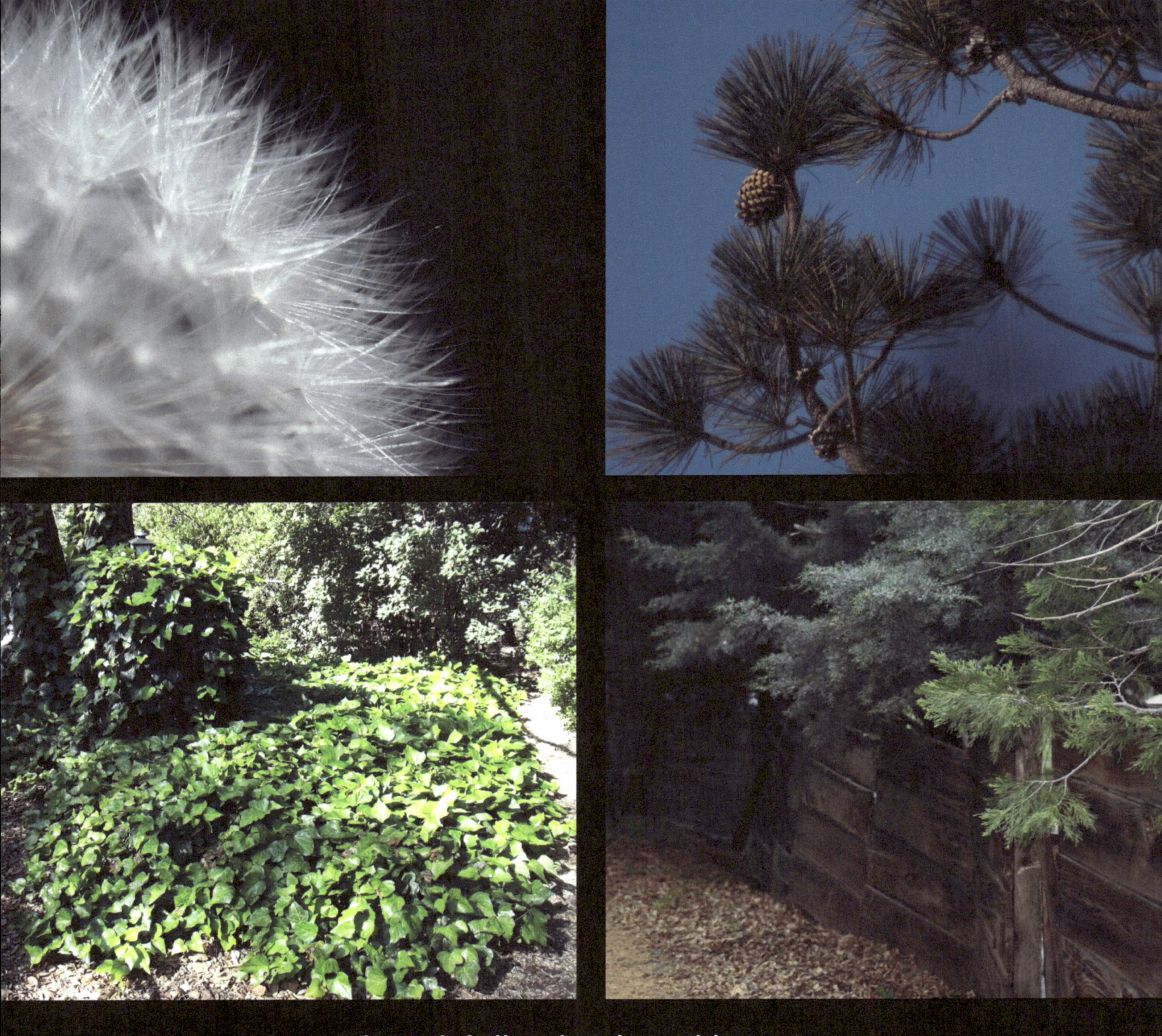
Local Julian backyard beauty

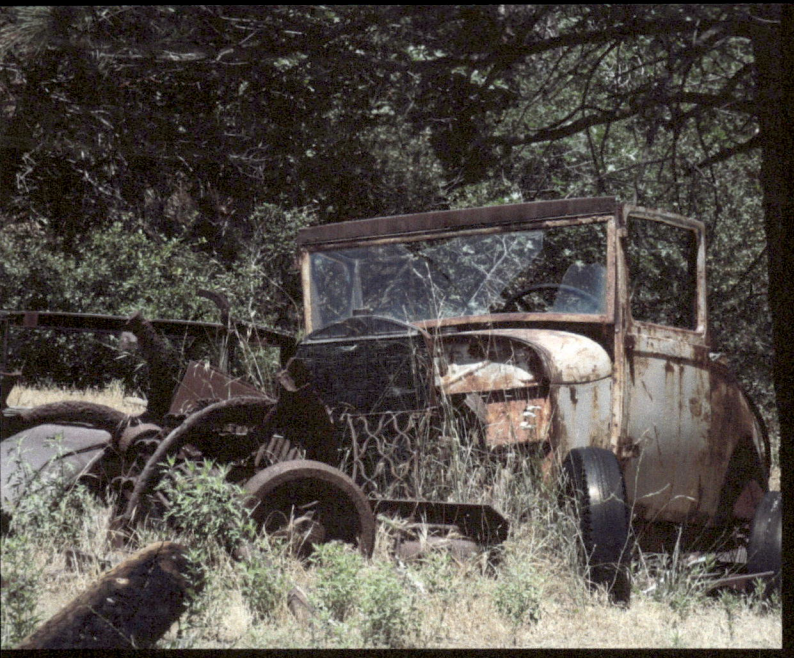

Rusty Things in Julian

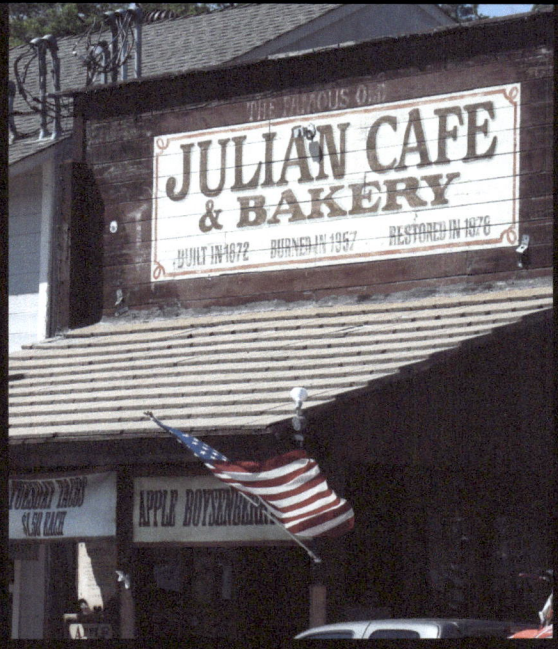

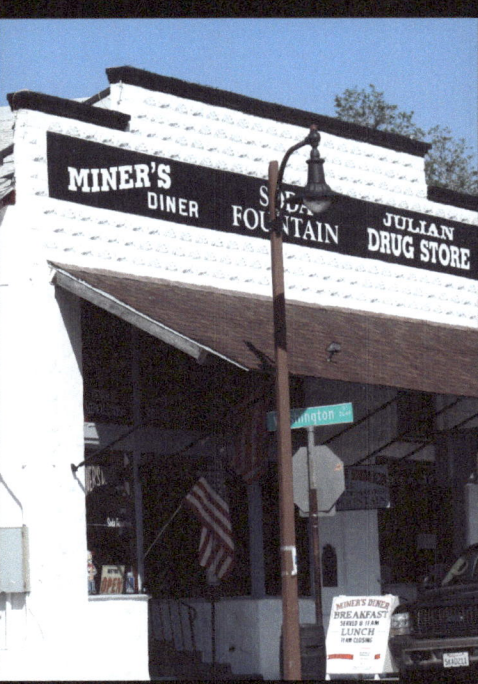
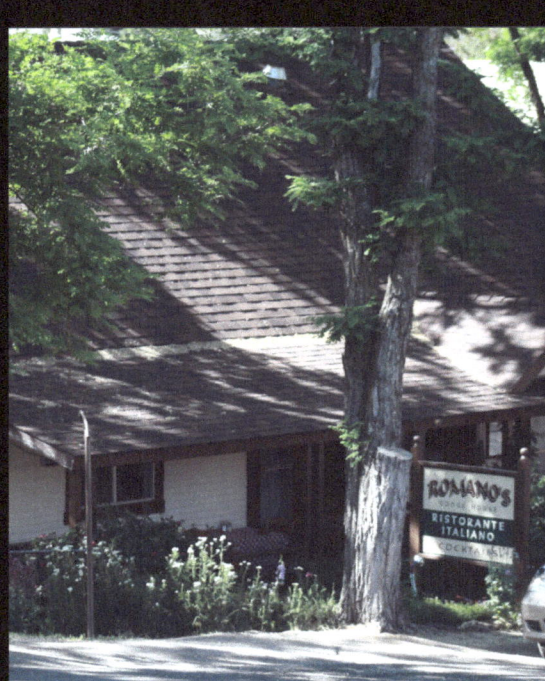

Some of the other buildings in downtown Julian

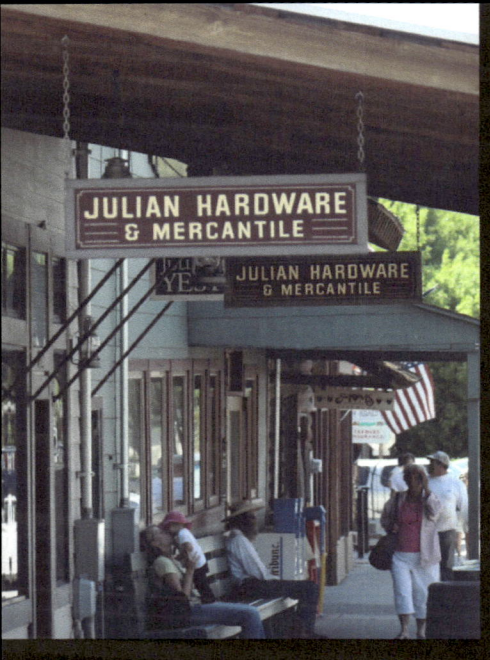

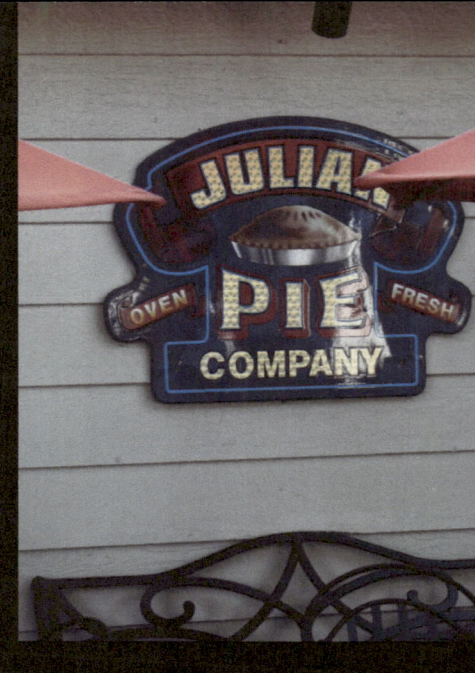
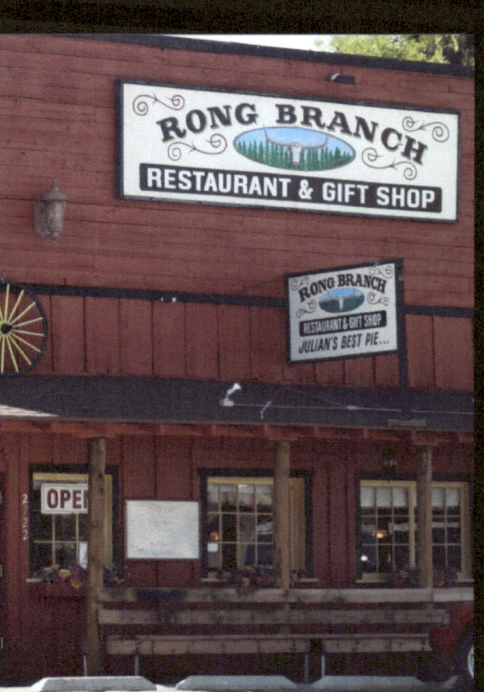
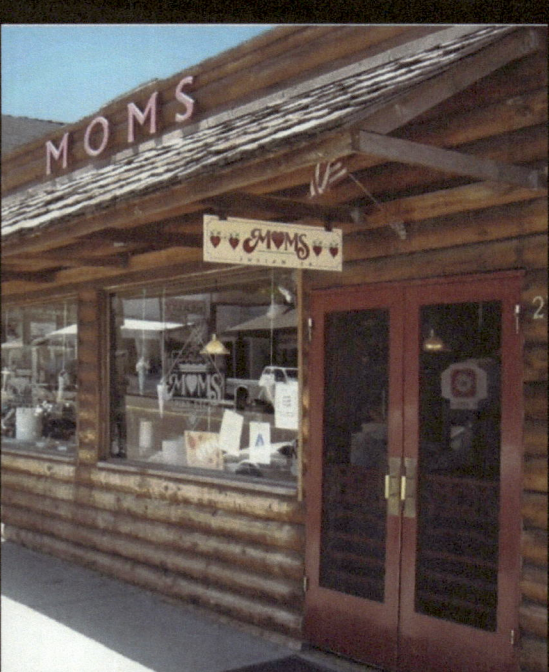
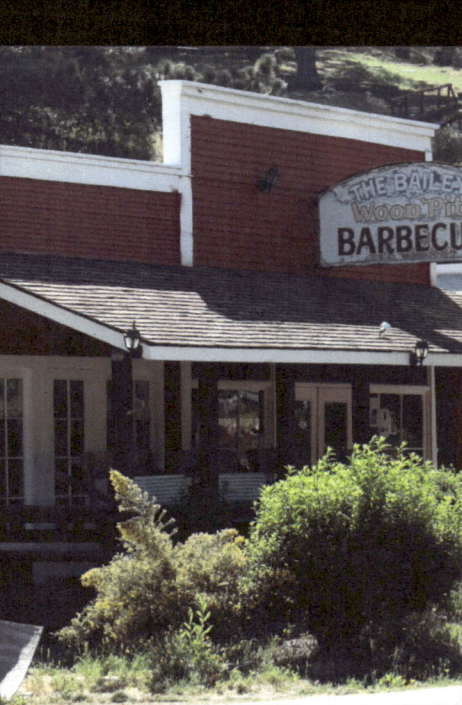

World famous Julian Apple Pie & downtown Julian

Some of the popular places downtown Julian

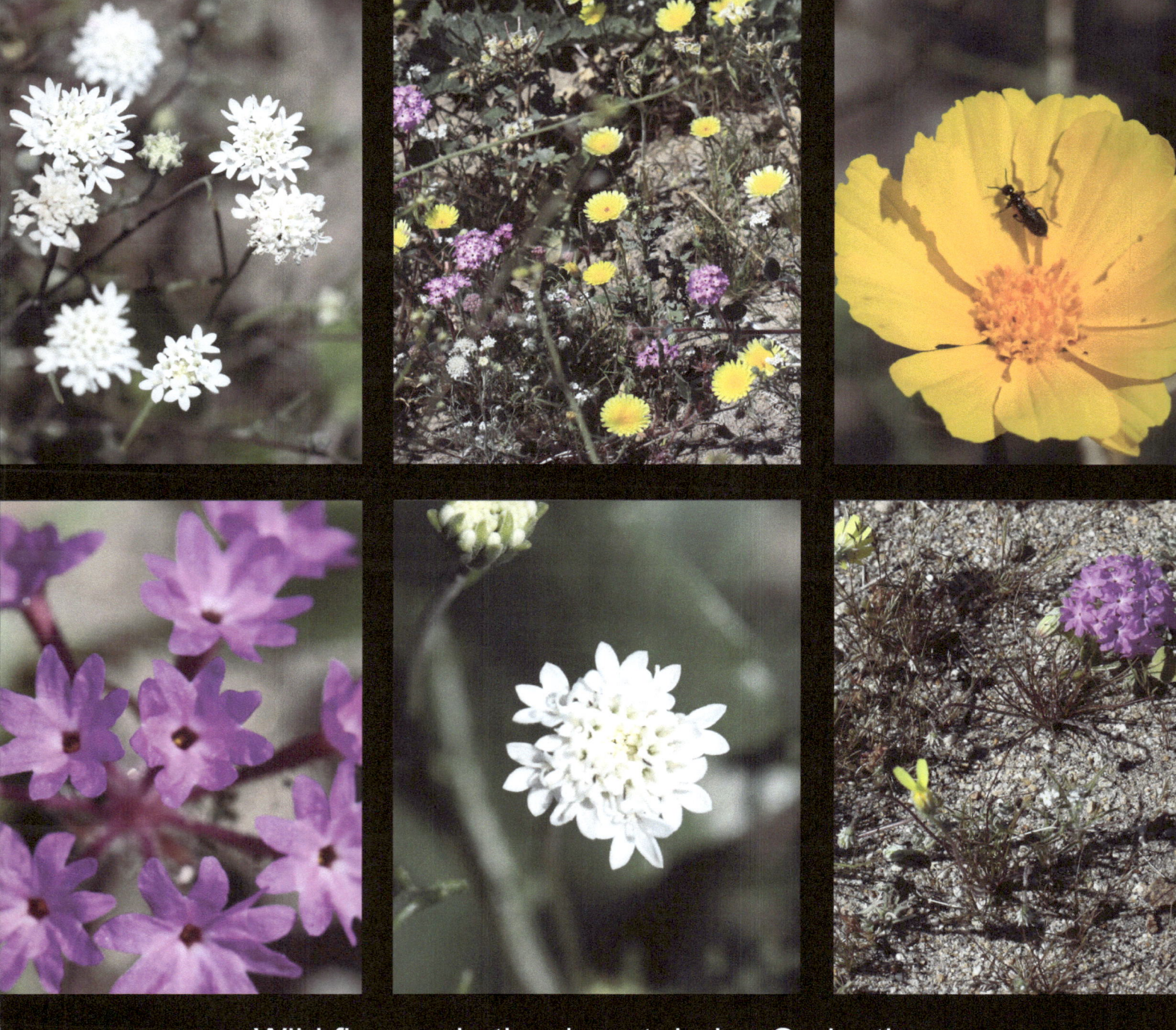

Wild flowers in the desert during Springtime

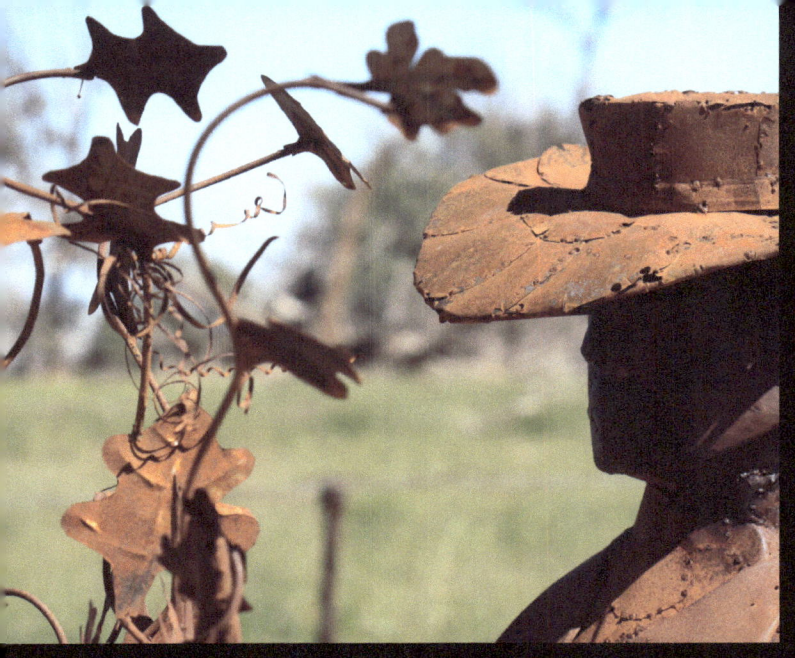
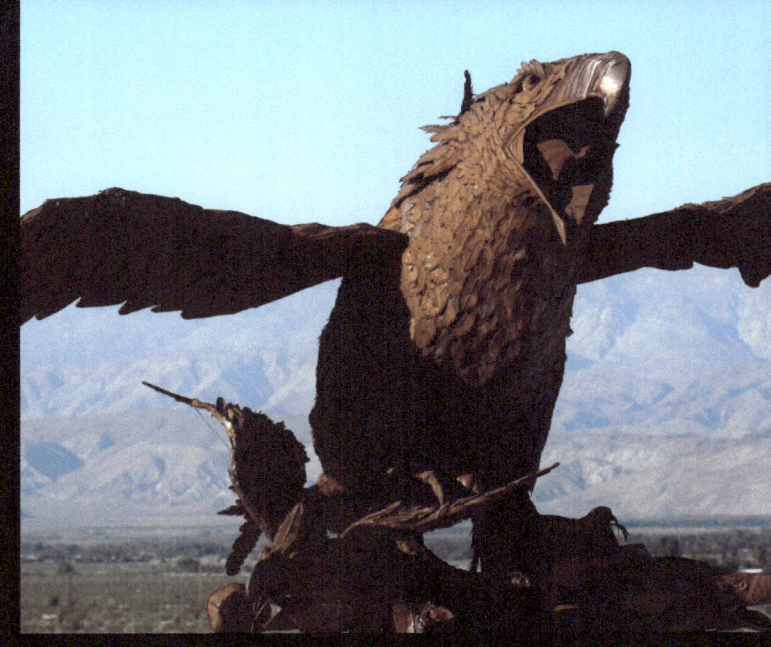
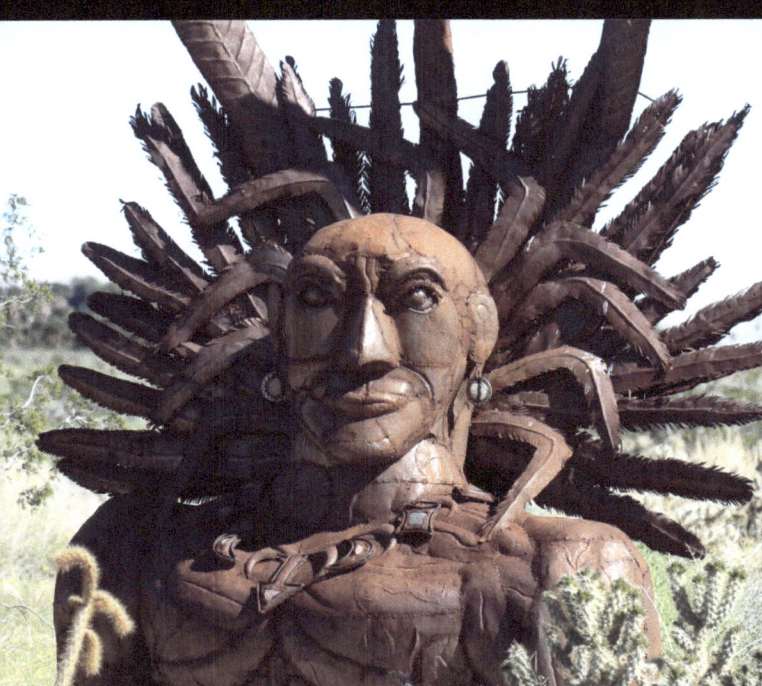
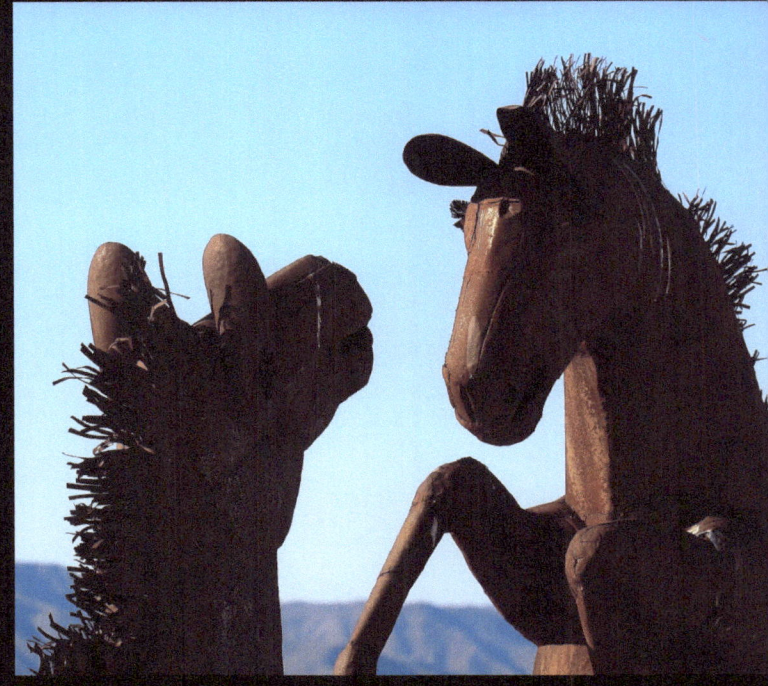

Metal Sculptures in Anza-Borrego Springs desert

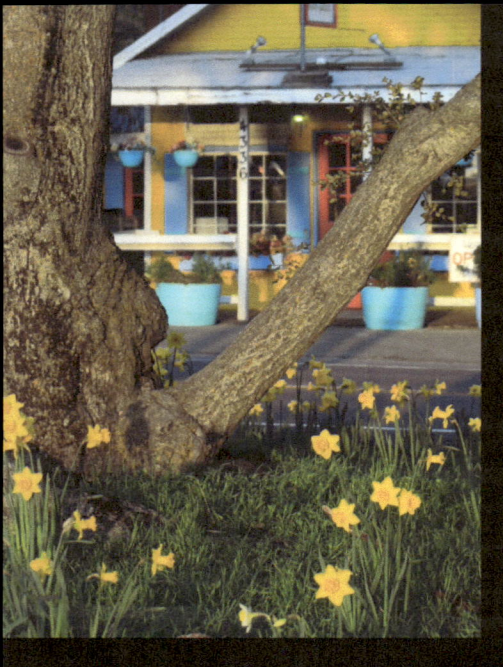
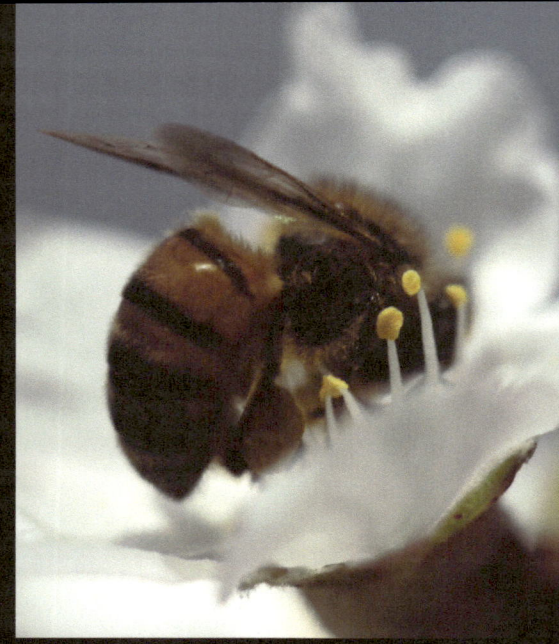
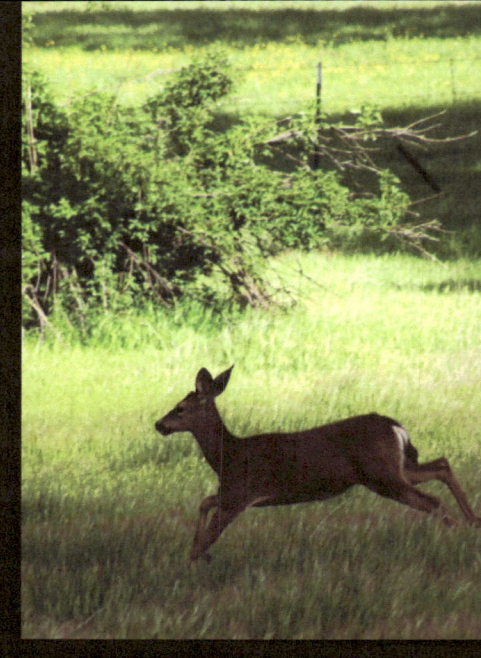

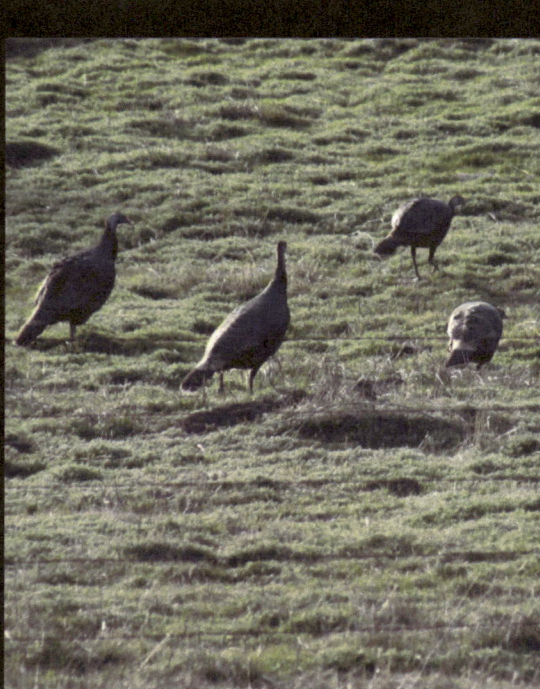
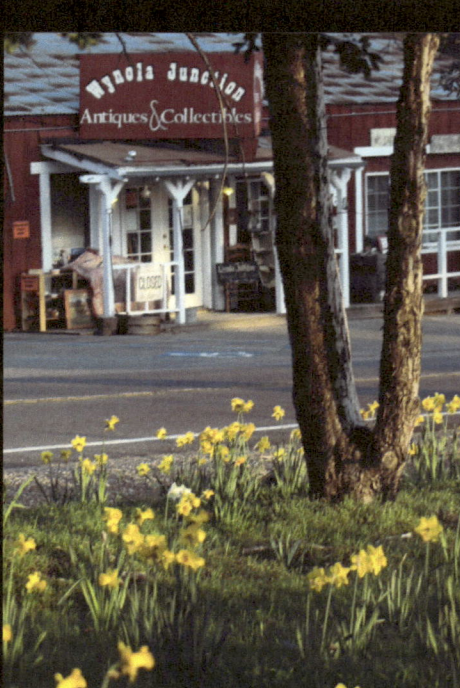

Wild daffodils & local wild residents of Julian

More rusty things from Borrego Springs and the back country.

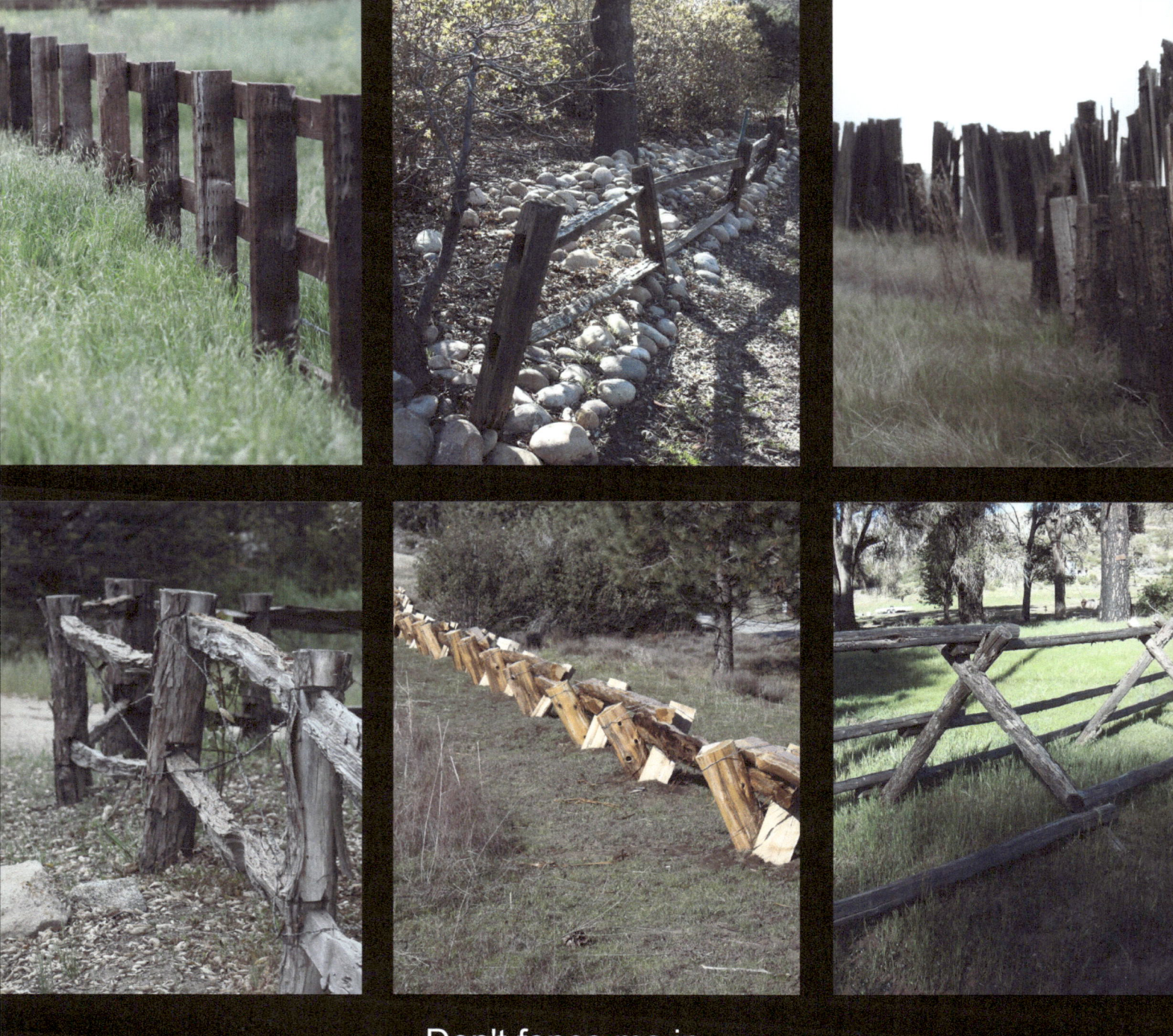
Don't fence me in........

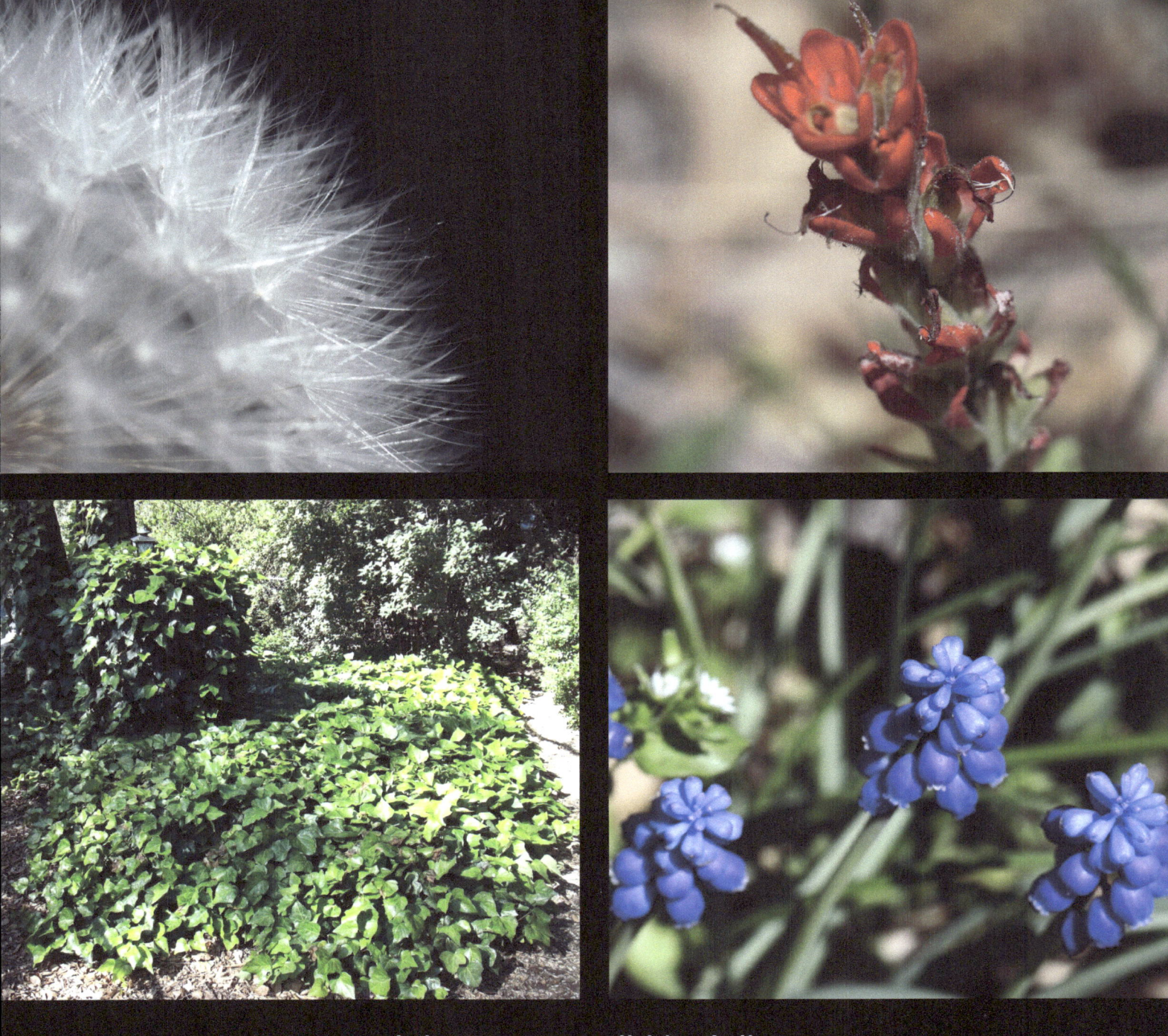
It just grows wild in Julian

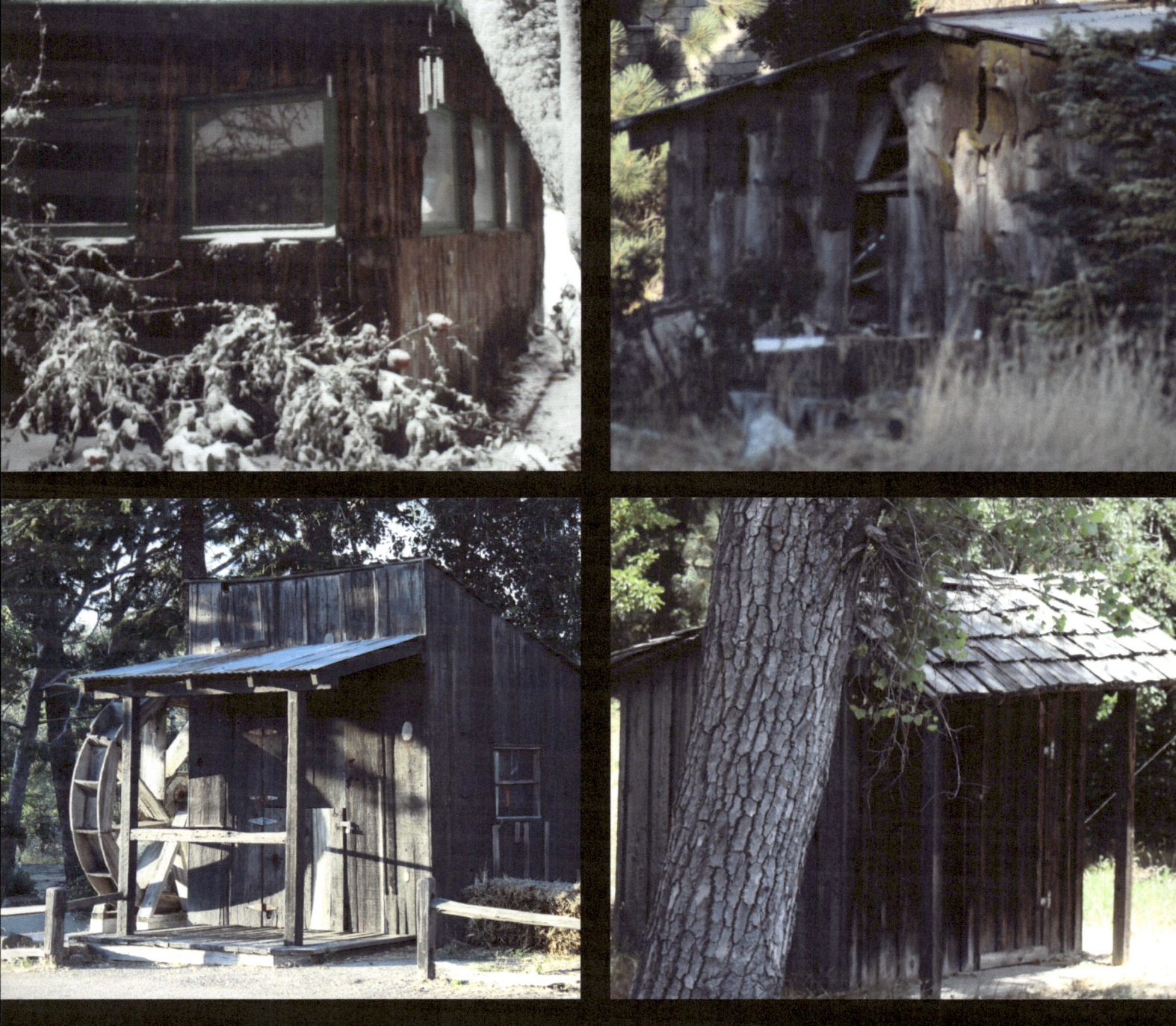
Some of the more older homes in Julian

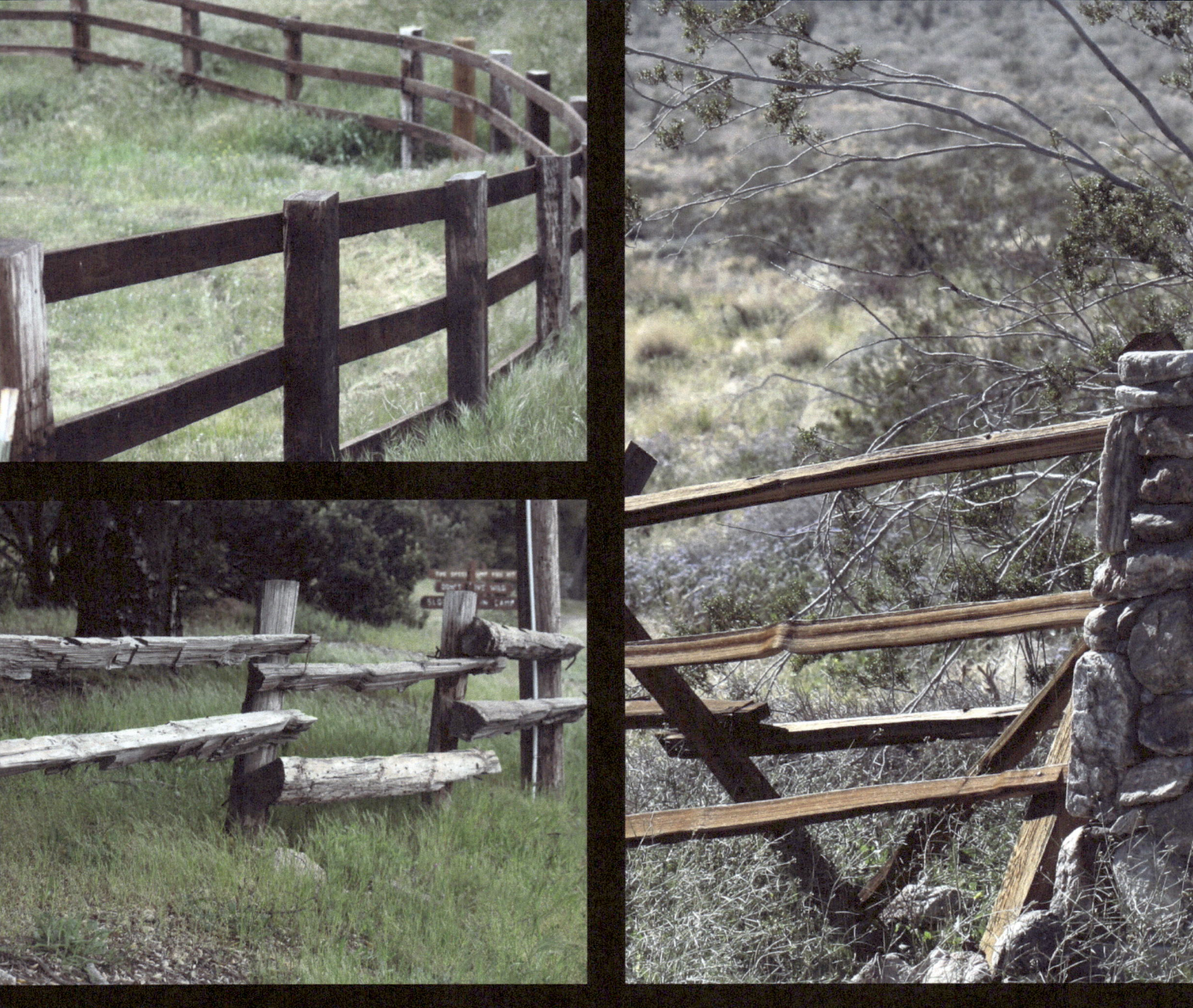
Fences..... you'll find them everywhere!!

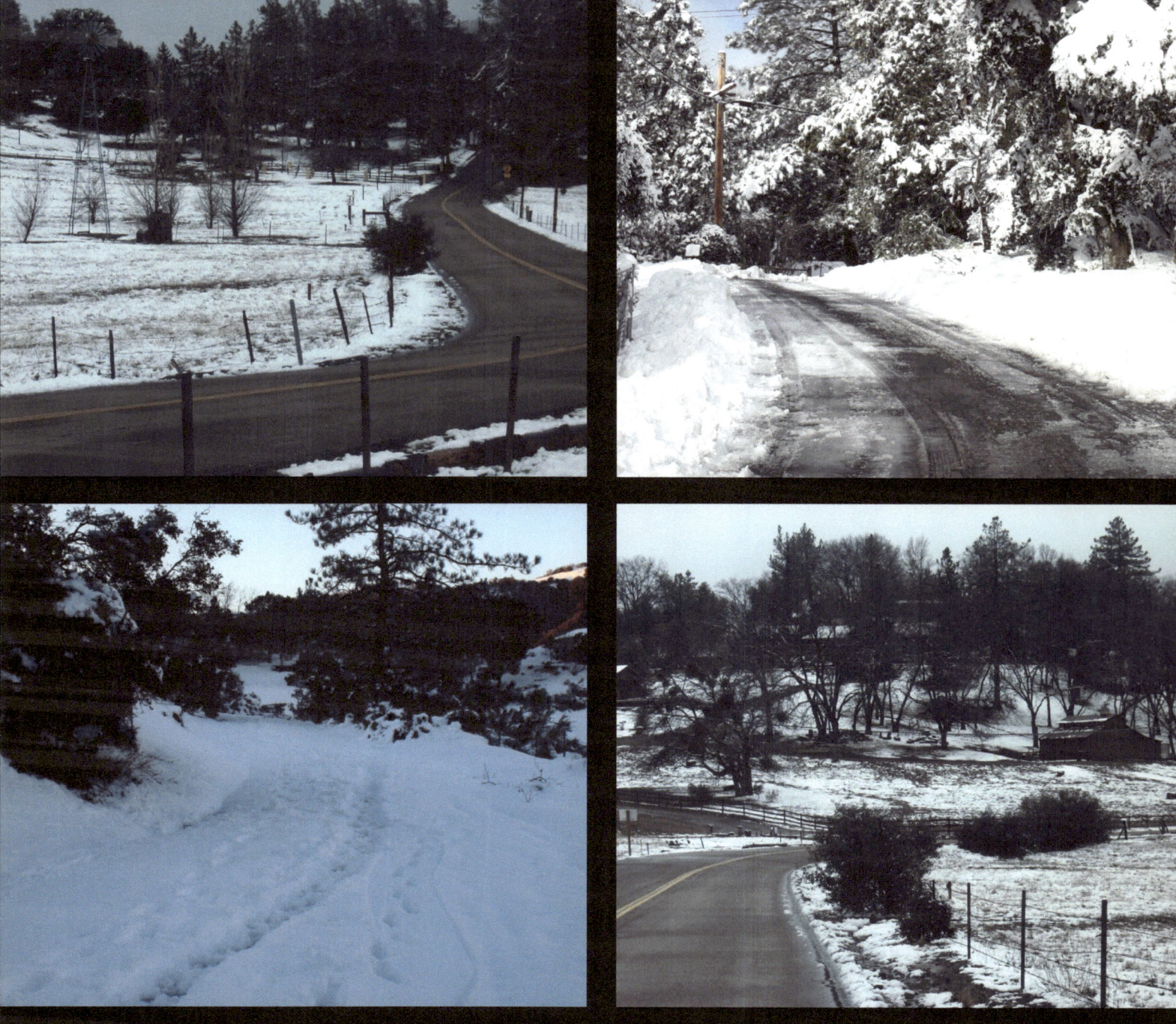

Snow roads in Julian

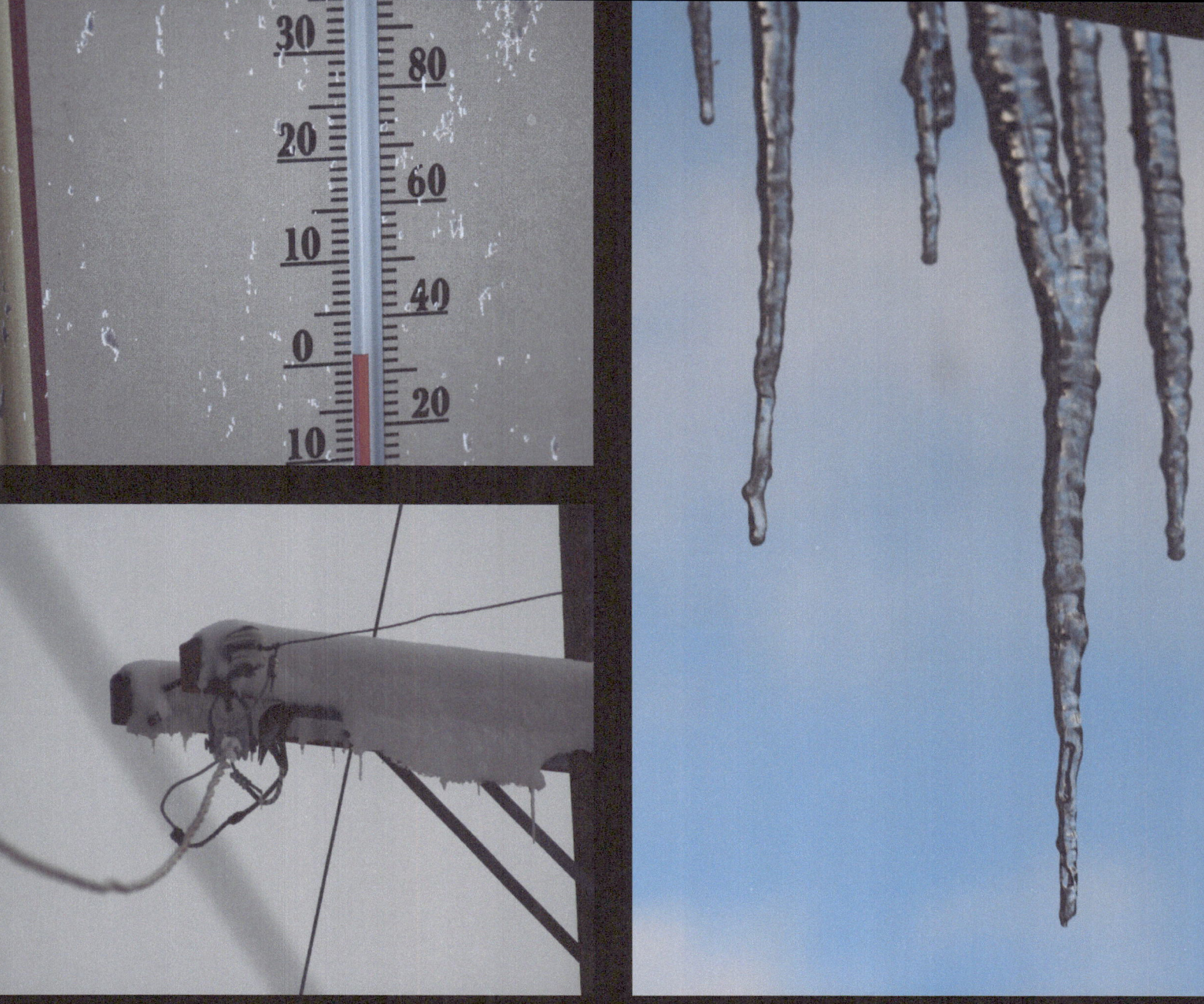
It got really cold last night!!

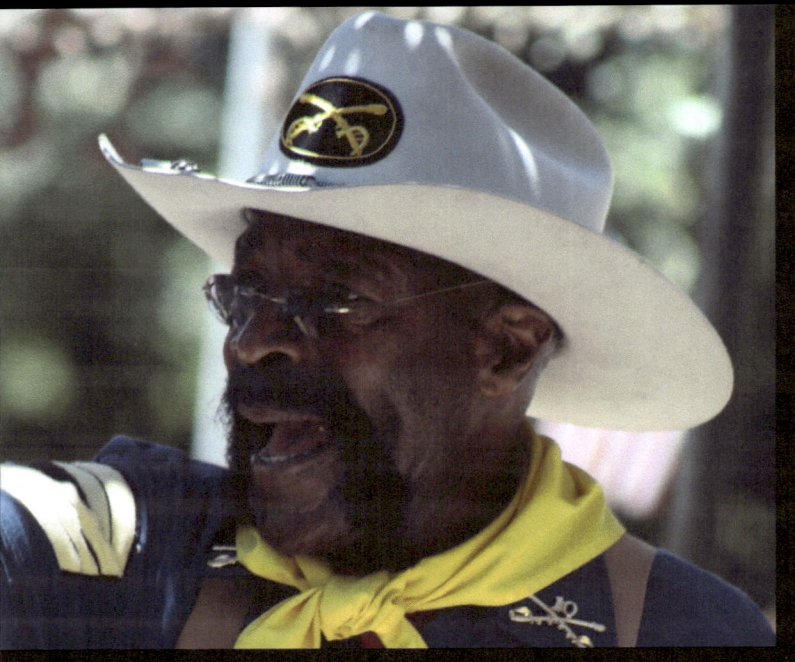
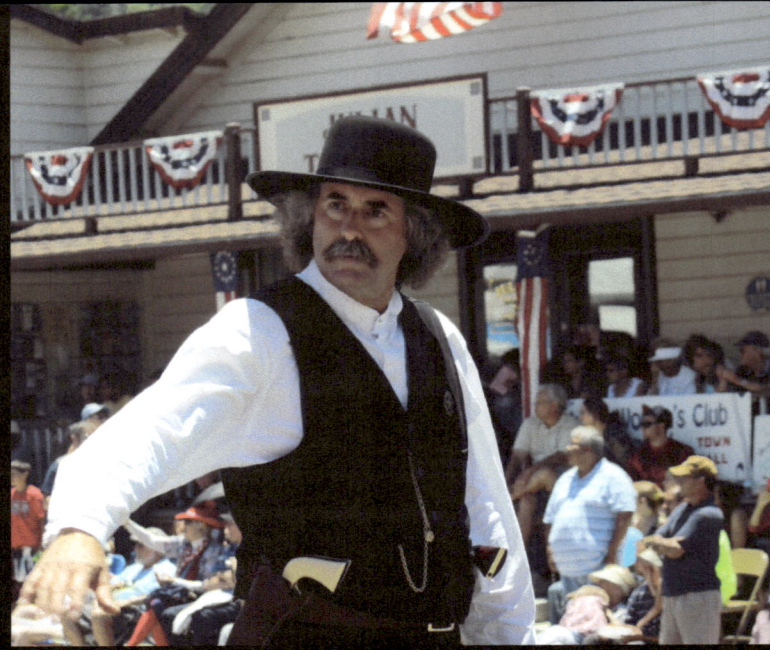

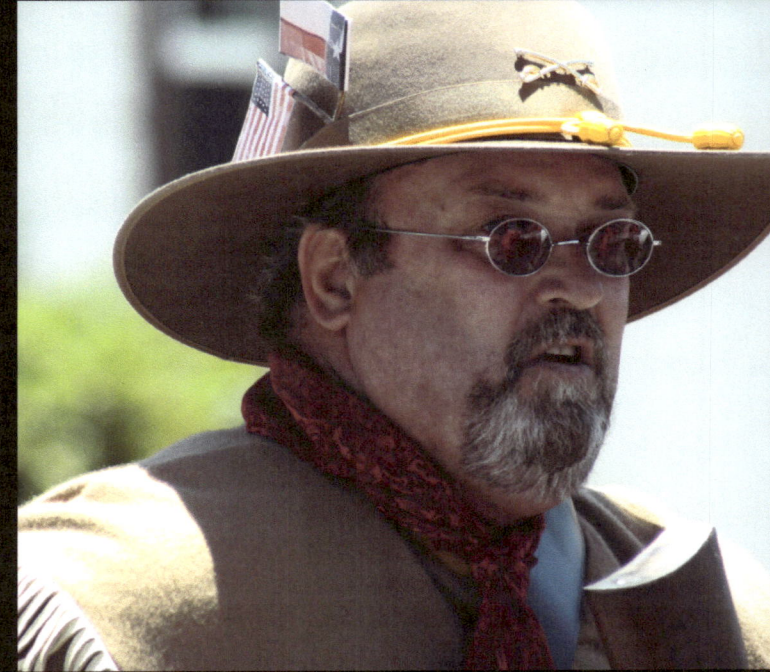

Long live Cowboys!!

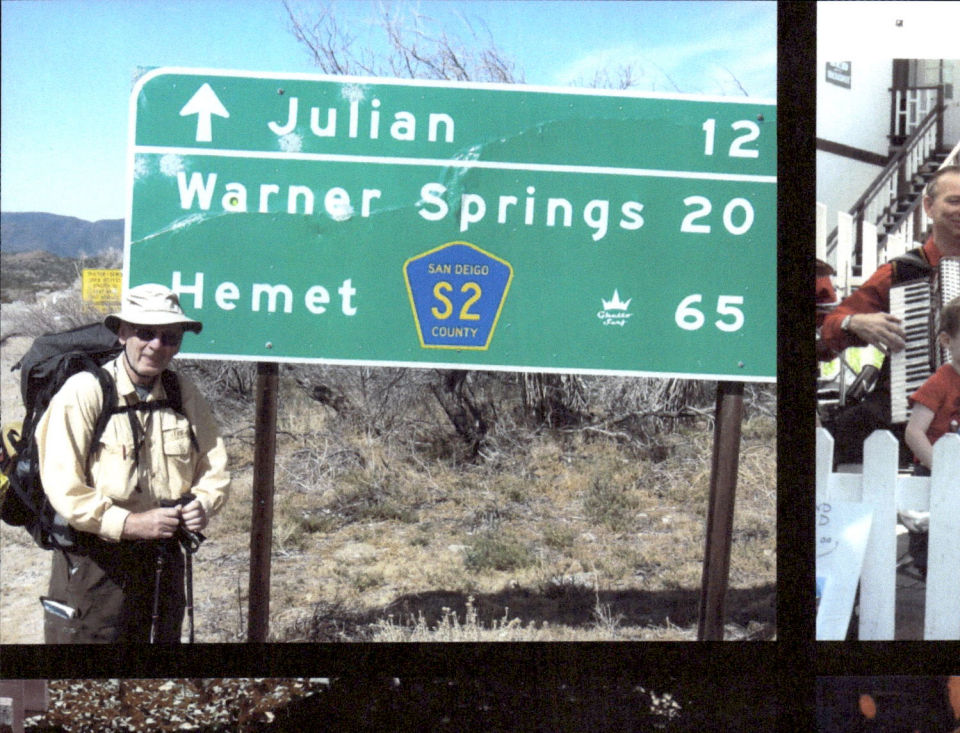
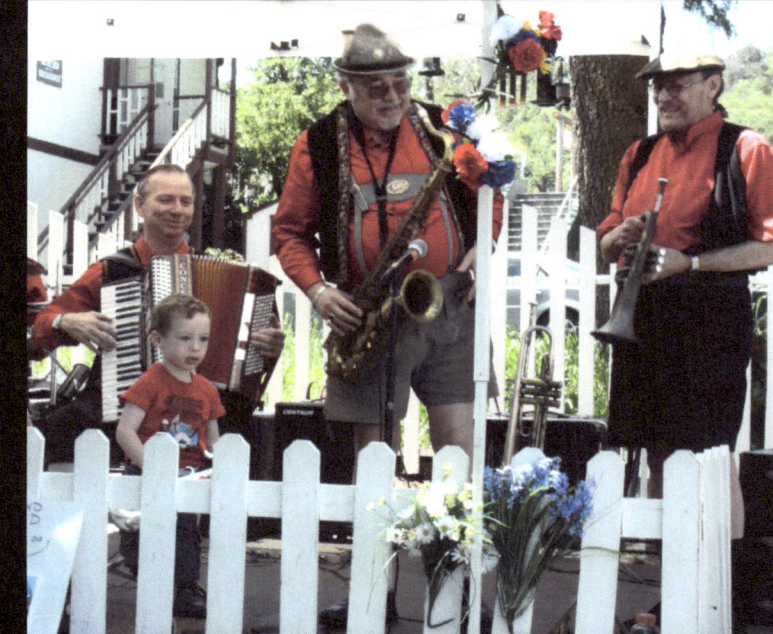
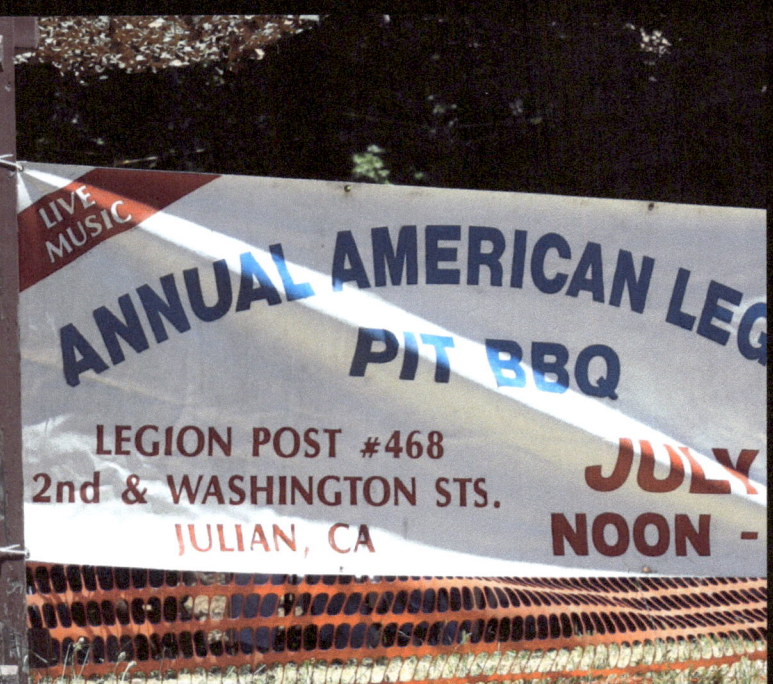
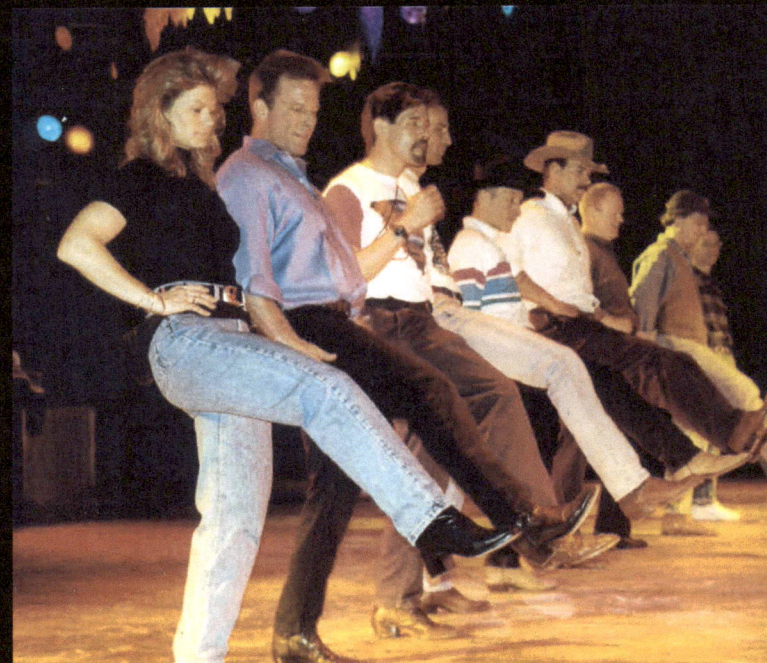

Hiking the trails, 4th of July Deep Pit BBQ,
"The Dance" in June & Mayfest in Julian

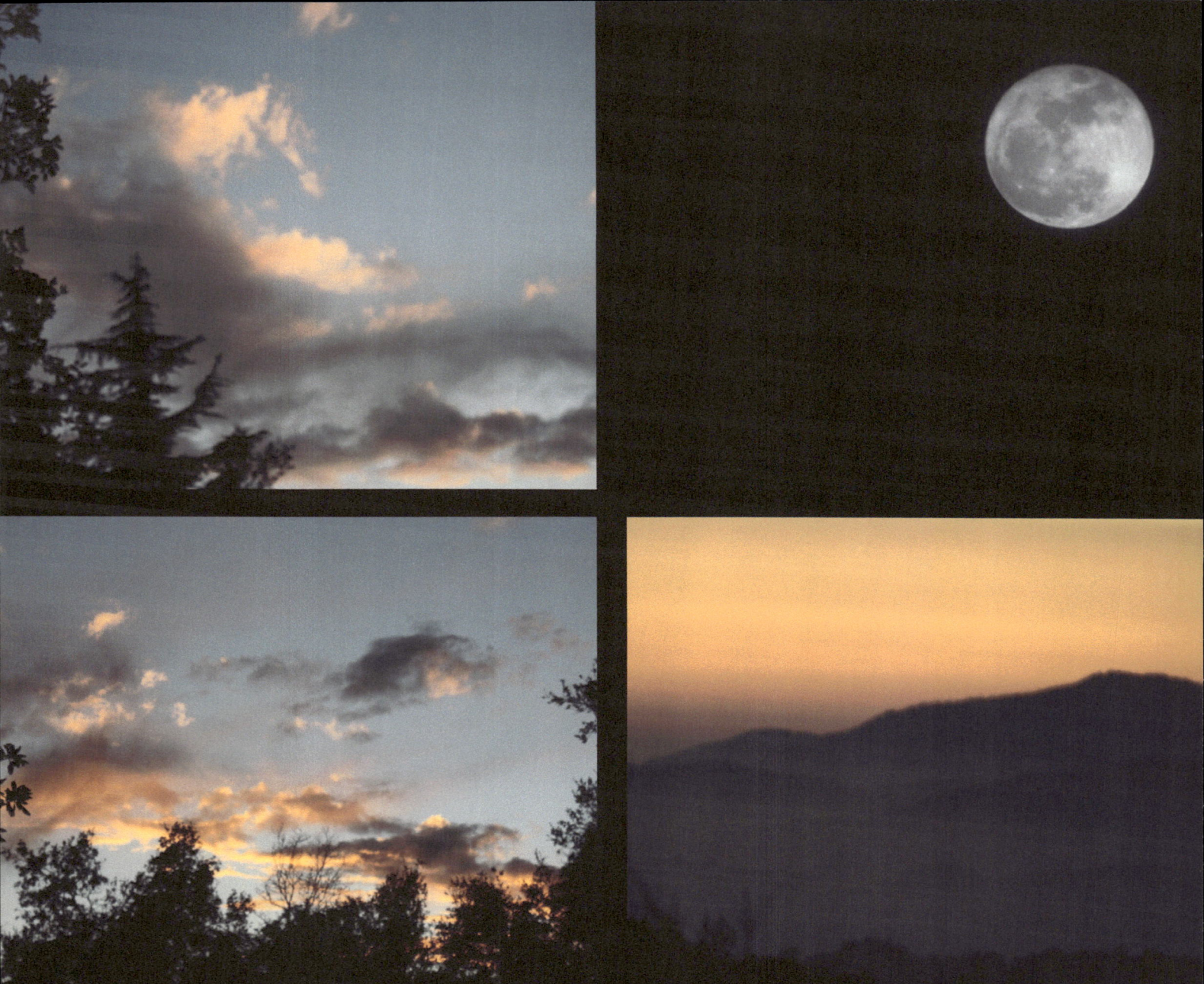

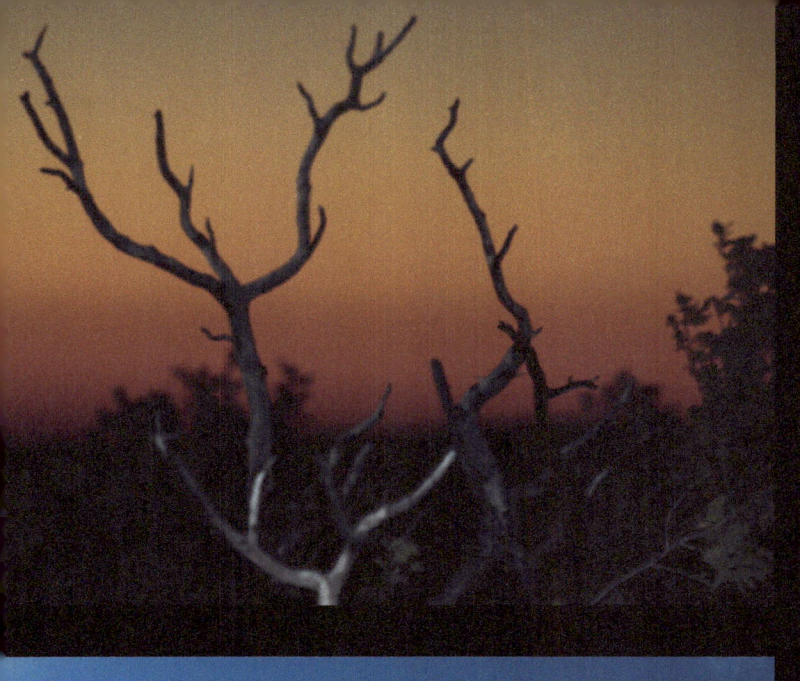

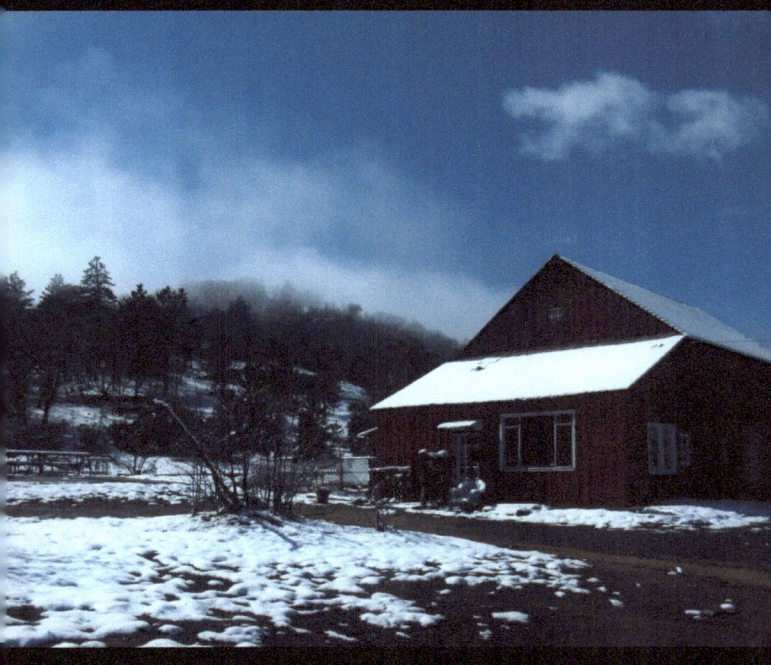
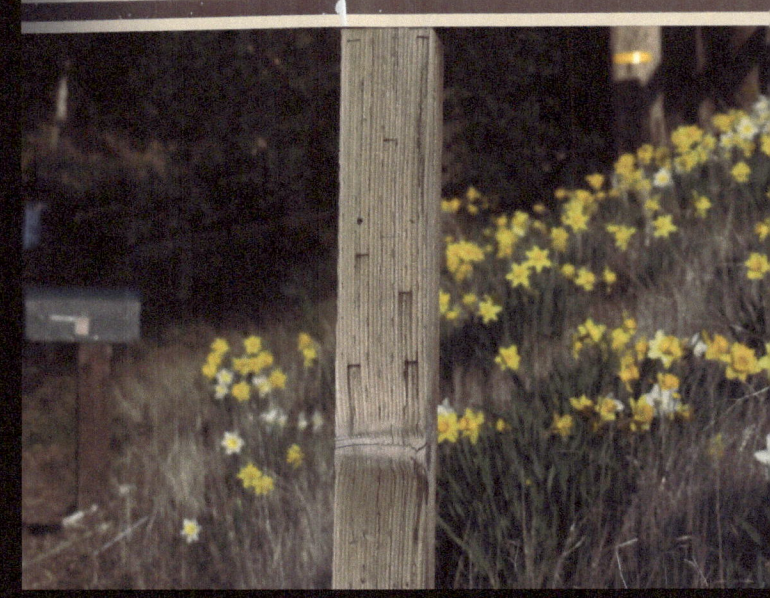

Contact for additional books & information: Ted W. Snoddy
Tvettes5@hotmail.com
P.O. Box 311 Julian, CA 92036 (760) 716-4226

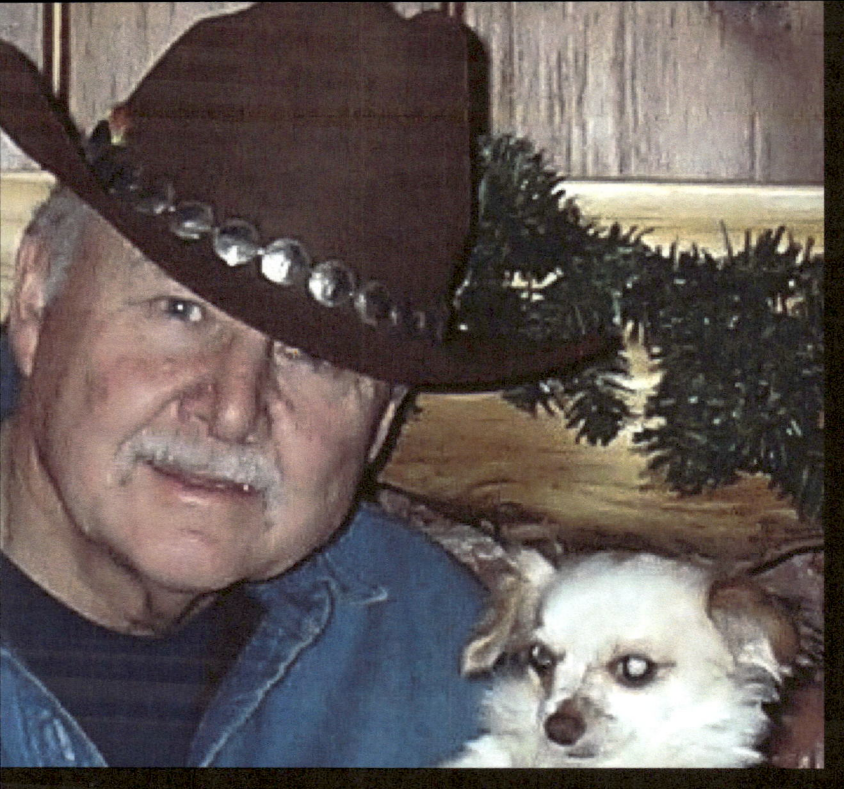

Ted Snoddy is a local resident and photographer in Julian. He uses a Canon EOS XS digital camera with a 18-55mm, 1:3.5-5.6 IS (image stabization) lens in his photo work. Generally capturing his subjects using both micro and telephoto lens as well.

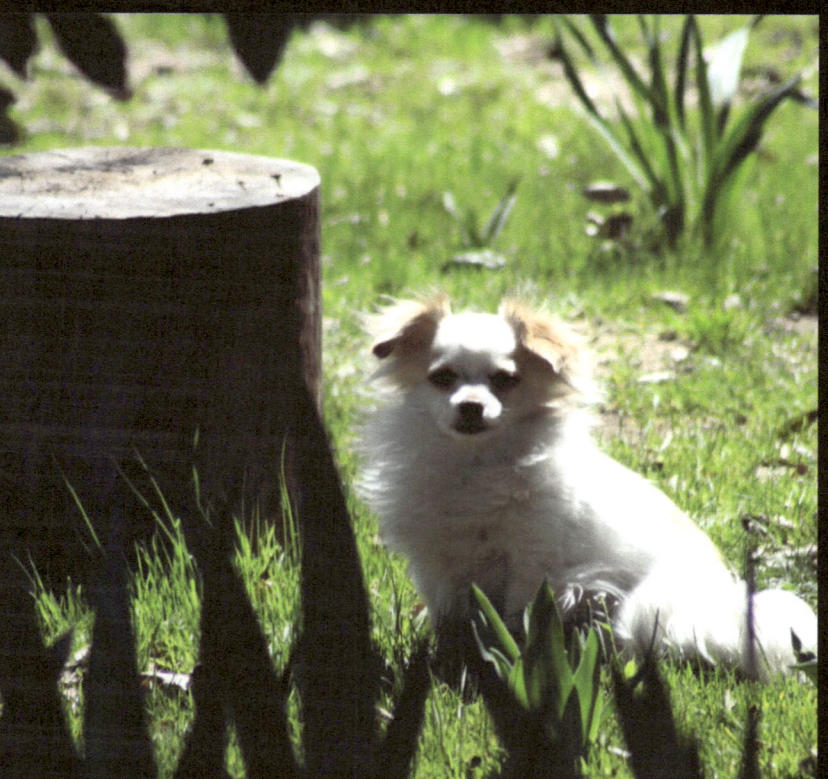

When composition is *everything*, he looks to blend natural light, camera angle, texture and color. He looks for that *"wow"* factor, folding his experience into making memories,*"one click at a time."*

If you see Ted out photographing you will certainly find his *Partner-in-Crime,* Teddy at his side!